ARTIST'S HANDBOOK:

PENCIL
DRAWING

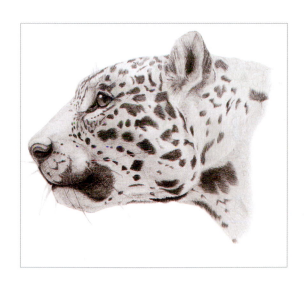

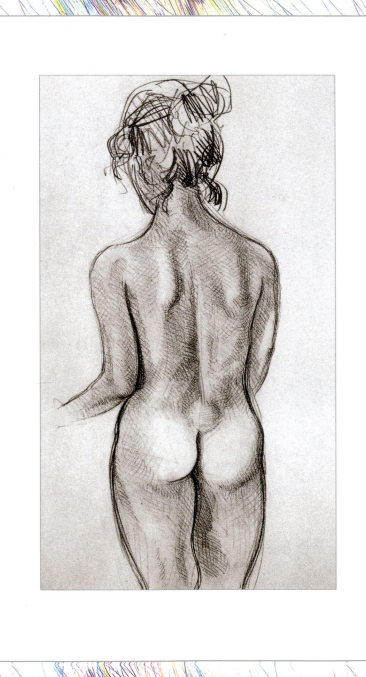

THE ARTIST'S HANDBOOK:

PENCIL
DRAWING

materials • techniques • color and
composition • style • subject

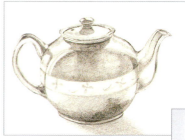

AN OCEANA BOOK

First edition for North America published in 2004 by
Barron's Educational Series, Inc.

Copyright © 2004 Quantum Publishing Ltd.

All inquiries should be addressed to:
Barron's Educational Series, Inc.
250 Wireless Boulevard
Hauppauge, New York 11788
http://www.barronseduc.com

International Standard Book No. 0-7641-5622-5

Library of Congress Catalog Card No. 2002107841

This book is produced by
Oceana Books
6 Blundell Street
London N7 9BH

QUMPAH2

Manufactured in Singapore by Pica Digital Pte Ltd.
Printed in Hong Kong by Paramount Printing Co. Ltd.

9 8 7 6 5 4 3 2 1

CONTENTS

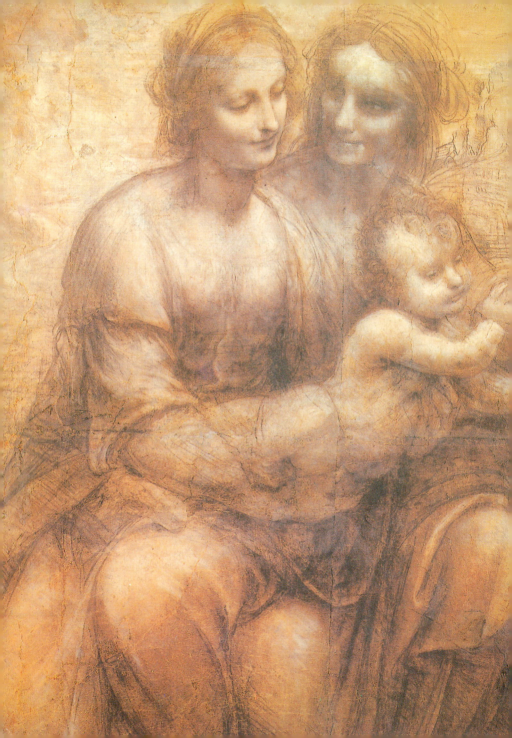

INTRODUCTION

Drawing can be many different things; it is possible to stretch the definitions to cover anything from a finely-worked objective study of the world-as-seen to an idea with a line around it! Throughout history, the master draftsmen have provided us with copious examples of the variety and scope that can be achieved by this method of making pictures. One way of attempting to define this many-sided subject is of recording what it cannot be. It cannot be listless, for instance; a sense of investigative urgency is the basis of good drawing and listlessness is its antithesis. While it can be bold, free, generous, and full, it cannot be undisciplined, for this means that the medium controls the image beyond the acceptable bounds of experimentation and new discovery.

INTRODUCTION TO DRAWING

Almost everyone can make a great variety of marks on a piece of paper – when someone bemoans the fact that they "cannot draw" they really mean that they have not learned how to observe. The quality of a drawing depends more on the artist's ability to observe, than on any special skill with pen or pencil.

The ideal drawing medium for each artist is the one which expresses his observations most directly. When an artist chooses a medium to draw with, he looks for the one which will become an expressive extension of his fingers, so that his hand and eye can work together with as little impediment as possible. Naturally this choice will be influenced by the nature of his observations: it would be difficult to say much about a delicate cloud formation with a laundry marker.

The great advantage of an ordinary pencil, provided it is not too hard, is that the strength of the mark it makes is open to considerable variation, from light to heavy. Pen and ink may seem less flexible by comparison, but a pen drawing by a great master such as Rembrandt is a reminder that it is not so much the nature of marks made on the paper that is important, as the quality of the observation that has informed them.

Provided that it is used to express form, almost any drawing medium can come to life. It can be instructive to draw the same object using as many different materials as possible, in order to find out which one is most successful for conveying space and volume. If the object is drawn as an outline, using a medium that gives too even a line will make the drawing seem flat and formless. It would be more appropriate to draw the outline with a soft pencil or some other marker that has variable strengths and tones. If there are strong contrasts of light and shade in the object, with large dark areas, then charcoal might be the most suitable medium.

THE MEDIUM

Pencil covers a wider range of medium than is commonly thought. The lead pencil is now quite an uncommon medium, although still available. The lead pencil's light, silvery, gray line can produce an effect not dissimilar to that of silverpoint which, before the innovation of the modern graphite pencil, was the main linear drawing instrument, particularly among Renaissance artists, although that too is in less common use today. The silverpoint and lead pencils make their mark by leaving a small metallic deposit on the paper, which in the case of silverpoint can barely be seen when the drawing is first done. The metallic deposit tarnishes, and this increases the richness of tone in the line.

The graphite pencil as we know it today is still often incorrectly called a "lead pencil." It is a relatively new drawing instrument and has been in common use only for about 200 years. It comes in a variety of grades. The softest grades are denoted by the letter B and range from B to 8B, which is the softest. F, HB, and H are in the middle of the range. H pencils are the hard range, from 2H to 8H. There are other grading systems but the H and B system is the most common. If in doubt, always test pencils before you buy them.

A useful alternative to the ordinary pencil, particularly for outdoor drawing, is the mechanical pencil, for which the "lead" is purchased separately. This is useful in that no sharpening is required and a fine line can be continuously maintained.

The solid graphite stick, normally graded approximately at 3B, is also very useful for larger, tonal, pencil drawings, and is often used in conjunction with a regular pencil. A number of artists recently have been drawing with raw graphite powder, rubbing it into the paper to make large tonal marks, then bringing out highlights with an eraser and more detailed areas with a regular pencil. This method is suitable for very large works.

A pencil can be used in a variety of ways but is most commonly employed in making a line; the result is a crisp, clear drawing. Shadow can be produced by hatching or cross-hatching, which is a set of parallel lines or two opposing sets of parallel lines, respectively. This approach has been widely used, and two of its greatest exponents were Raphael and Michelangelo.

THE HISTORY

Lead or graphite pencils are a comparatively new medium in the long history of graphic art, for it was not until 1662 that the first graphite pencil was made. Graphite had been discovered in Bavaria in 1400, but its potential for the artist remained unexploited until the first English find of pure graphite in 1504 at Borrowdale in Cumberland. The popular but misleading designation "lead" pencil stems from this discovery, as the deposit was at first thought to be lead. Only later was graphite identified as a separate mineral and even then did not receive its present name until 1789.

Jean Auguste Dominique Ingres (1780–1867) is considered by many to be one of the world's greatest draftsmen. His study for the portrait of Louis François Bertin reveals the great emphasis that he placed on line work. Eugène Delacroix (1798–1863), Honoré Daumier (1808–1879), and Edgar Degas (1838–1917) were among those most influenced by Ingres' tight drawing and smooth accurate line, although, as they matured, they developed very definite styles of their own, Daumier, for instance, drew mainly from memory, using loose-knit lines, seemingly endless and curling, as in his rapid pencil sketch of *A Group of Men.*

Paul Cézanne (1839–1906) makes fear visible in his sketch of a *Boy Surrounded by Rats*, and in his *Dog Studies* employs very fine cross-hatching to show tonal variations and shadows. Pierre-Auguste Renoir (1841–1919) reveals his love for the body in his pencil study for *The Bathers*, with its soft, merging curved lines.

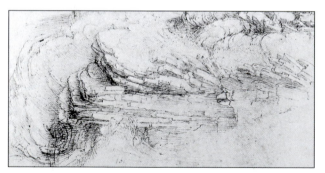

The notebooks and many drawings of Leonardo da Vinci are evidence of his restless interest in a vast range of subjects. He was extremely inventive in developing descriptive drawing techniques for recording his observation of people, objects, and natural effects. A sketch of a rock formation details the layered structure and the shift from a series of horizontal wedges into curling and angled forms thrusting upward from the main rock bed. The delicate linear style of the drawing produces an atmospheric effect.

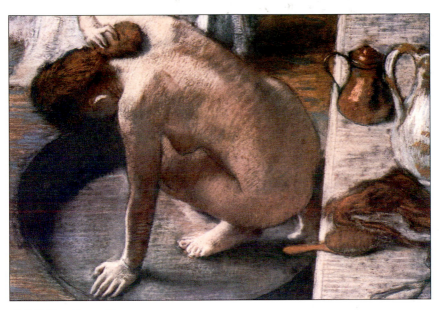

THE TUB BY EDGAR DEGAS
Degas has used pure pastel, strong colors, and a simple composition for this drawing. The strokes sometimes move across the body and sometimes with it, a technique which imbues the work with life.

SILVERPOINT

Until the development of the graphite pencil most sketching and preliminary designs for painting were carried out with a brush or charcoal, or with silverpoint. This precursor of the pencil was a stylus of silver or a similar metal, and to produce its characteristic delicate silver-gray lines called for a specially prepared background. It was a medium favored by many great artists, including the German artist Albrecht Dürer (1471–1528), who sketched his *Reclining Lion* (1521) with fine silverpoint hatchings and shadings on white paper. Leonardo da Vinci (1452–1519) drew a study for the *Virgin of the Rocks* on light-brown prepared paper, while Rembrandt (1606–1669) drew his wife *Saskia in a Straw Hat* with silverpoint on white prepared vellum (1663).

Modern silverpoints may be inserted into a pencil holder or into an ordinary lead pencil that has been split, the lead removed, and the two halves glued together again. The silver tip should be kept rounded off with a sandpaper pad otherwise it may dig into the support.

MATERIALS

Every brand of pencil has its own handling qualities — the pencils are usually sold singly as well as in sets, so it is worth trying out a few different types. As well as variations of texture, the color ranges vary between brand-name products, and you should keep in mind the versatility of the palette if you decide to buy an expensive boxed set.

The surface finish of the paper you use also significantly affects the pencil application. Some artists like a grainy paper with a rough tooth that breaks up the color, others prefer a smooth finish that leaves all the textural qualities dependent on the way the marks are made. Ordinary drawing paper is fine for practicing your skills, and is often used for finished work. But if you want to get a special effect making use of the paper grain, check out the range of papers sold primarily for watercolor and pastel work.

VARIETIES OF PENCIL

Manufacturers grade graphite or "lead" pencils according to their relative hardness or softness. The commonly accepted scale runs from 8B (the softest) through 7B, 6B, 5B, 4B, 3B, 2B, B, F, HB, H, 2H, 3H, 4H, 5H, 6H, 7H, to 8H (the hardest). Another system employs a scale from 1 to 4, with 1 being the softest grade.

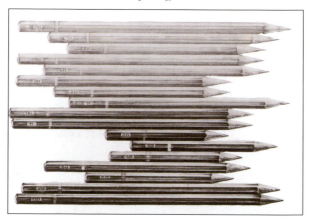

The range of leads here are numbered from 8H (very hard) to 8B (very soft). To illustrate this range, each pencil was drawn with the appropriate pencil.

GRAPHITE POWDER

Graphite powder can be made by scraping against a graphite stick with a sharp knife. Applying the powder with a stump, a pencil-shaped tool of rolled soft paper, produces a subtle mark that you can use in preference to rubbing with a finger, which makes an unspecified, vague mark.

HOLDING THE PENCIL

Unlike writing, when your hand rests on the paper, a drawing grip should enable you to make wide movements and keep your hand off the paper, to avoid smudging. Practice making marks on scrap paper until you feel comfortable holding a pencil lightly, grasping it well away from the point.

Always work with a sharp pencil; blunt points make uncontrolled marks. For faster, broader marks try using solid graphite sticks, with the same composition and grades as pencils. Use the side of the stick for broken or rapid covering, after scraping off any protective lacquer.

HANDLING PENCILS

The conventional grip in which the shaft of the pencil rests in the curve of the thumb, with the tip guided by your thumb and first two fingers, gives tight control. You can make very delicate marks, firm lines, and even shading by small movements of the fingers, wrist, and hand. For more open, scribbled, or hatched textures, you can use more sweeping movements of your hand and arm.

Alternatively, you can grip the pencil with your hand curled over or under the shaft. These grips give less subtle control but encourage free gestural movements of the hand and arm. For instance, shading with an underhand grip can be very light and quick, while linear marks made with the overhand grip can be heavy and vigorous.

If you are experimenting with a change of scale or textural variations in your work, it is always worth trying different ways of physically manipulating your medium.

CONVENTIONAL GRIP
The common method of holding a pencil, similar to the grip used for writing, gives tight control over line work and shading. Holding the pencil higher up the shaft gives you a freer handling method for loose shading and hatching, and you can also approach the drawing from different angles.

OVERHAND GRIP
If you hold the pencil with your forefinger over the shaft, rather as if you were stabbing something with a fork, this tends to encourage firmer

pressure. It is a good way to develop dense shading, or to produce a strong line quality.

UNDERHAND GRIP
This method in which you cradle the pencil in the palm of your hand, confines the movement of the pencil tip. Applying pressure with thumb and forefinger, you can produce a heavy but sensitive line quality – to make the line your whole hand moves, not just the wrist and fingers. Underhand shading has a lighter touch and you can vary the pressure just by lifting your fingers slightly.

CHARCOAL

Charcoal is made of sticks of wood, often willow, burned to carbon. Various grades are available, ranging from hard to very soft, and the latter particularly need to be fixed to the surface of the paper on completion of the drawing. This is normally done by the use of a proprietary brand of fixative.

Recent times have seen developments and changes in charcoal, as in so many other materials. Charcoal pencils, containing compressed powdered charcoal and a binding agent, offer more control and a cleaner instrument with which to work. The density of mark will vary according to the proportions of pulverized charcoal to oil (or wax); a softer pencil contains more binder, a harder one less. In general a toothed paper or board is most suitable for use both with sticks and pencils.

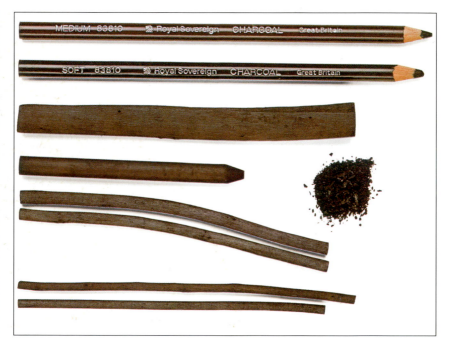

From top to bottom: two compressed charcoal pencils in medium and hard, thick charcoal stick, compressed charcoal stick, two medium charcoal sticks, two thin charcoal sticks, and powdered charcoal.

COLORED PENCILS

There are many types of colored pencils available, each with its own distinctive character and uses. Standard colored pencils have a dense, hard core that makes a shiny, waxy mark on paper. There are two types: both can be used directly on paper, but the water-soluble kind can also be used to create rich color washes. They are very useful when planning watercolor washes, as they blend into washes well and do not show through. Colored pencils are very clean to draw with, which means that you can sketch with them without fear of making a mess. Pastel pencils, on the other hand, have a soft, brittle, dusty core that makes a mat mark, which can be blended with a stump, but can rub off if not fixed. You can use pastel pencils to create sharp definition or hatched detail in soft-pastel drawings, or for making color notes, or sketching on a moderate scale.

AQUARELLE PENCILS

Aquarelle pencils look like traditional colored pencils, but their cores are water soluble. Hard and soft types are available, hard pencils being precise on wet paper and useful for adding fine details, and soft ones for making strong washes and reinforcing shades. They can be used as dry pencils, but the pigment dissolves when it is washed with clean water, making it possible to blend colors. You can draw over dry washes and rewash if necessary, but because wet aquarelles stain the paper instantly, make sure the wash has dried completely before reworking.

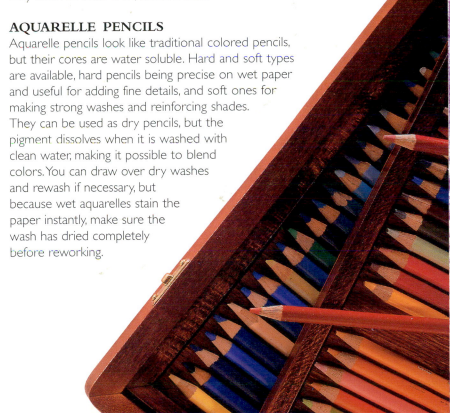

OTHER EQUIPMENT

SKETCHBOOKS

One of the most interesting aspects of the work of any artist is to be found not perhaps as would be expected in the finished drawings or paintings, but in the preliminary attempts and exploratory drawings in the sketchbooks. Sometimes large, used to record in detail the world as seen and sometimes small, the right size to carry in the pocket and have with you in all situations, a sketchbook of some sort will provide the artist with the opportunity to record, reflect, and reminisce.

If you prefer a small, pocket-sized sketchbook, the quality and type of paper should match your intentions. Color and tone notes require a well sized, lightly textured paper while a smoother surface is more suitable if most of your notes are to be made in ballpoint pen. A good quality paper, however, should take any medium adequately and allow you a certain amount of choice.

Sketchbooks are available in all types and sizes. Those with a spiral binding are particularly useful, as in the type with tear-off perforated sheets; some come in a book form so that it is possible to work right across the spread, or with a little ingenuity you can make a sketchbook yourself, to your own specifications. Although a pocket size can be carried easily, not all sketching is done on a small scale.

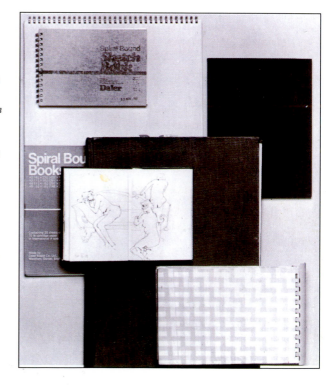

ERASERS

Nearly all hard erasers have some adverse effect, however small, on the surface of the paper. The familiar India rubber is efficient but inclined to become dirty and can cause bad smudging. Plastic and Artgum erasers are better in this respect, but Artgum erasers have the drawback of crumbling so much in use that the paper has to be constantly "swept," with the consequent risk of damage to the drawing. Best of all are kneaded or putty erasers. As well as being cleaner in use than other erasers, they can be molded into any shape, including a delicate point to pick out a small error. They can also be used to reveal areas of white paper to pick up highlights.

Several types of eraser are commonly used. A putty rubber is useful for picking out highlights from shaded areas. Modern plastic rubbers and the Artgum eraser will remove most lines without smudging.

SHARPENERS, KNIVES, AND BLADES

Pencil sharpeners are useful but not as easy to control as blades or knives, and have the irritating habit of breaking off the lead just as it is sharpened to a suitable point. There is a special sharpener made for sharpening the leads in mechanical pencils.

Scalpels and craft knives are among the most useful adjuncts for the draftsman, although a one-edged safety-razor blade is an efficient, if less safe, substitute. A pencil that has been properly sharpened with a blade will reveal more lead and retain its point longer than one sharpened by a pencil sharpener. Blades can also be used to scratch out pencil marks that are impervious to an eraser – although this should be avoided where possible.

FIXATIVES

For graphite, charcoal, pastel, and chalk, fixatives play the role of a binder similar to that of oils, gums, and glues in paint. They can be bought ready-made, either in aerosol spray cans, or in bottles so that they can be used with an atomizer or mouth spray attachment. Alternatively, an acceptable protective varnish or fixative can be made up by adding two or three parts of alcohol to one part of white shellac.

PAPER

GETTING STARTED

The surface of a particular paper determines the effect of media on it. There are three types of surface classification: "hot-pressed" (HP) is smooth, "cold-pressed" (CP) has a slight texture, or tooth, and "rough" is unpressed, with a visible raised tooth. The fiber content of paper ensures its longevity. Don't use cheap machine-made newsprint for drawing, it quickly becomes brown and brittle because its fiber content is made of wood, which has a high acid content. Most inexpensive drawing papers and sketchbooks are made of a mixture of wood and other fibers: these are still acidic and are acceptable for rough work, but not for much else. Better-quality paper is neutralized to counteract acidity, and is usually labeled "acid-free." Modern "mould-made" papers are manufactured by machine from new cotton fibers, but have many of the same qualities as handmade papers; buy these in roll form if possible, as cutting your own sheets is a great saving over buying ready-made books and loose paper. Handmade papers may seem expensive, but they are worth considering, particularly for water-colors, where some tooth is helpful.

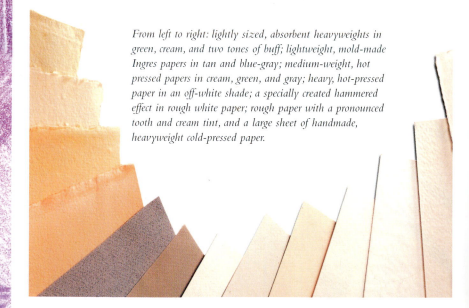

From left to right: lightly sized, absorbent heavyweights in green, cream, and two tones of buff; lightweight, mold-made Ingres papers in tan and blue-gray; medium-weight, hot pressed papers in cream, green, and gray; heavy, hot-pressed paper in an off-white shade; a specially created hammered effect in rough white paper; rough paper with a pronounced tooth and cream tint, and a large sheet of handmade, heavyweight cold-pressed paper.

CUTTING PAPER

Ideally, it is best to use a paper cutter for cutting paper, but, if you don't have one available, here is a method that will enable you to tear paper neatly.

1 If you have to tear by hand, use a bone folder (or smooth plastic substitute) to press in a crease first.

2 Paper has a "grain" and tears more easily one way than the other. If you find one direction difficult, start from the other side.

Paper mills produce numerous variations, so try out samples until you find what you like. Hot-pressed paper is best for pen work, but other media can slide on this, so try cold-pressed when using pencils, charcoal, or soft pastels.

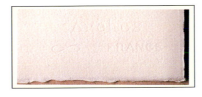

TYPES OF PAPER

Paper is sold in loose sheets of various sizes as well as in sketchbooks in both landscape and portrait formats. Match purchases to the media you intend to use: smooth, hot-pressed paper for pen work, cold-pressed for pencil and chalk, and rough paper with a heavy tooth for wet media. Remember that transparent watercolors exhibit a color bias because the ground shows through.

BUYING PAPER

Shop around for good types of paper, as different paper mills vary widely in their choices of surface, weight, and price. Look for sale bargains or sample swatches of paper, and be prepared to experiment. It is worth trying Asian-made papers, which are made of bamboo, rice, jute, and other plant fibers. Colored papers are useful as toned grounds for pastels, chalks, and charcoal, but they may be acidic, and some cheaper types fade quickly. Store paper in a dry place and don't keep it in acidic wrapping.

WHERE YOU WORK

Drawing requires little cumbersome equipment and is not dependent on an elaborate studio set up. Do not be put off by photographs of major artists posing in spacious, custom-built studios; an intelligent analysis of real requirements and the best way of utilizing available space will reveal many possibilities.

INDOORS

Few drawings are larger than 20 × 30 in. (60 × 76 cm) – most much smaller – and even when using acrylic or oil paint the average size of work is likely to be much smaller than might be imagined. By gearing the space available to the likely size of the work to be made in it, sensible solutions can be found.

This does not mean that it is impossible to produce larger pieces. Some artists have worked in an area no more than 10 × 10 ft (3.5 × 3.5 m), managing by using a system of rolling larger works – painting or drawing only one section at a time as they roll up the completed end. The danger with this method is that the essential overall view will be lost, resulting in the picture falling apart visually when seen as a whole. In general, the average requirements should be assessed and space and equipment employed accordingly.

In addition to a bench or easel you will need a small, conveniently situated surface containing your materials. This should be accessible to the working hand so as to avoid the danger of making blots on your work or knocking things over. Simplicity and common sense should be your guidelines, with as little clutter as possible, not only to minimize risks of accidents but also to reduce peripheral "visual noise." To this end it is best to have white or neutral walls, with unpatterned curtain material, thus avoiding the distraction of competing colors intruding on the retina.

Light is a vital factor in making images – preferably constant and even and traditionally north light. This last requirement is not essential, and it is sufficient if the window is large and clean enough to admit plenty of whatever light is available. What is more important is the location of the easel in relation to the light source, and making the best use of artificial light when this is necessary. For a right-handed artist, the light should come over the left shoulder, and vice versa, to ensure that no shadow falls across the drawing from the working hand. Artificial light should be similarly positioned. Overhead lighting can be adequate, but it is preferable if the bulb used is color corrected. These bulbs, usually blue in color, are readily available and are useful in that they allow work to continue after natural light has faded.

OUTDOORS

When working outdoors the main requirements are compactness and portability. The weight of materials to be carried and the speed with which the working situation can be set up are very important. For these reasons, the sketch book and sketch pad are extremely popular and useful items, often superseding the drawing board and stretched paper which were previously in common use. A wide range of these books and pads is available from good art supply stores, in a variety of sizes and surfaces.

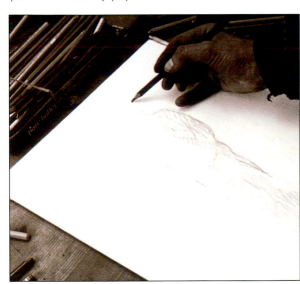

There are no hard and fast rules about the way in which you should organize your materials for drawing; so much depends on the style of your work and the media you use. It is, however, essential to adopt some sort of sensible system so that you are not held up by being unable to find a particular piece of equipment at a critical moment. Ensure that you position yourself so that your working hand neither smudges completed areas nor blocks the light from your support.

CHECK LIST

INDOOR MATERIALS
Easel, desk, or table
Chosen medium
Erasers
Fixative
Prepared support

OUTDOOR MATERIALS
Portable easel (if required)
Pencils or other drawing implement
Sketchbook, sketchblock, or paper stretched on drawing board
Erasers
Fixative

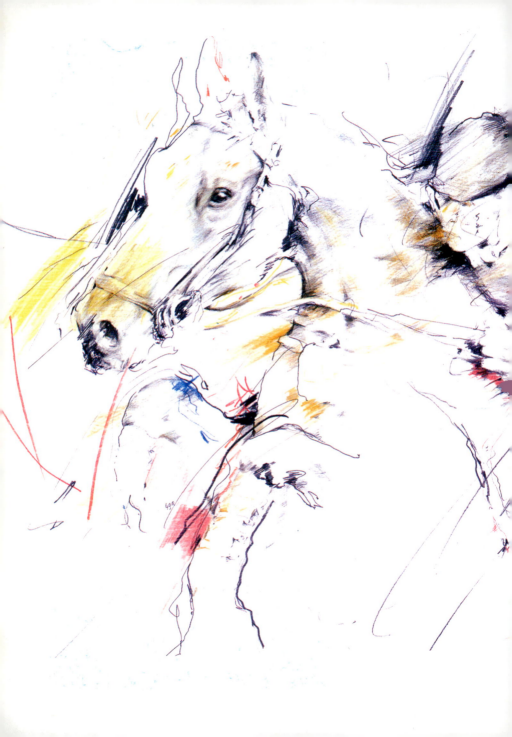

TECHNIQUES

Always start with a sharp pencil. This advice applies particularly to the softer grade of pencil, as well as to charcoal and carbon pencils. Unless these are kept well sharpened they will produce coarse thick lines that will spoil the effect of your drawing. Softer pencils are excellent for quick sketches, requiring less pressure than the harder pencils that demand more accurate control.

Pencil lines vary in appearance according to the speed with which they are drawn, the pressure exerted on the pencil, and the grade of pencil used. Hatching and cross-hatching, dots, short jabbed lines, marks and lines in random directions, fine lines, thick lines, thick lines trailing into fine, all these can be used to create tonal differences.

Different textures can be achieved, either on grainy paper or by drawing on paper laid over a textured surface such as wood, stone, or cement, and much fine color work can be accomplished with colored pencils.

AUTOMATIC DRAWING

The practice of automatic drawing developed from the theories of automatism and is usually associated with the Surrealists and artists such as André Masson (b. 1896). Foregoing any attempt at conscious planning, marks are drawn over the paper or canvas. The pencil is allowed to record the free movements of the arm, the gestures of the artist guided by, and revealing, his subconscious. This technique was explored by the American Abstract-Expressionist artists of the 1940s, most notably Gorky (1904–1948), de Kooning (b. 1904), and Pollock (1912–1956).

Some degree of automatic mark-making is evident in the drawings of most artists. The particular way that an artist holds his pen or habitually moves his hand or arm when he draws can produce involuntary and characteristic marks. These automatic marks can identify an artist's work just as handwriting reveals its writer; and in the same way as handwriting, they give an insight into the artist's personality.

The carefully placed horizontal marks made with a brush in Cézanne's watercolor drawings tell us much about the careful analytical way

he attempted to record space. The more nervous, agitated marks of a quill pen in van Gogh's landscape drawings betray a more emotional response to the subject. Even if a deliberate attempt is made to eliminate automatism from drawings, it is probably impossible to achieve unless drawings are made entirely using automatic drawing instruments.

Automatism can be profitably exploited by the artist, but it needs to be used with discretion. The danger can be that the automatic marks go further than merely revealing the artist's personal imprint and instead make the drawing "mannered," obscuring the information that the drawing is intended to convey.

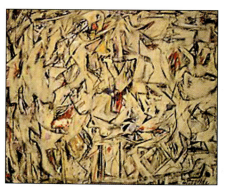

EXCAVATION BY WILLEM DE KOONING

In this painting, the sheer energy of the painted surface binds together shattered figural and natural forms. Whatever de Kooning specifically intended by his title for this work, it certainly reflects his painting process of intensively working his forms and surface over and over until the desired effect is achieved.

Dots and squiggles drawn quickly in the center of a sheet of paper and guided largely by impulse suggested to the artist the idea of foliage. By adding a few simple vertical strokes the automatic marks were transformed into the base of a tree.

In this drawing the artist drew rapidly keeping his eyes open. The subject was again a townscape and the medium a ballpoint pen. Visual control has produced a more familiar image but the impulsive way it was drawn has resulted in vigorous and inventive marks.

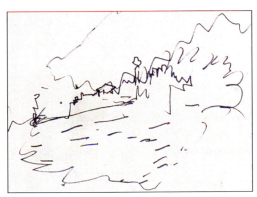

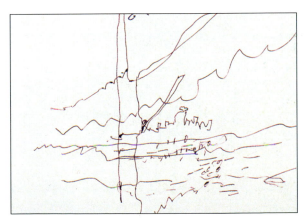

The artist chose a ballpoint pen for this drawing, because it runs easily over the paper in any direction and produces an unbroken line. With eyes tightly closed the artist imagined an urban scene and allowed hand and pen to wander over the paper guided only by thought or physical impulse. The result is a lively image, clearly a townscape yet also open to imaginative interpretation.

BLENDING

To achieve a gradual transition from light to dark or from one color to another various blending techniques can be used. The rich tones of a charcoal drawing can be merged together by rubbing them lightly with the fingertip. This smudging technique is also suited to pencil, conté, and pastel drawings.

Blending can create the subtle effects that depict the softness of folds in velvet or the hard forms of a machine. In a landscape it can produce misty, atmospheric effects. But don't overdo it. Not all tonal or color transitions need to be blended and too much use of the technique can drain the vitality and contrast from a subject.

A *torchon* (literally a twist of paper) made of tightly wound paper can be shaped with sandpaper to a point and is effective for delicate or detailed blending, especially with pastel. Try using a soft rubber eraser to blend colored pencils.

When drawing with watercolor or ink, different techniques are needed. Washes can be blended together by laying a wet dark tone against a wet light one and letting the water do the work. This merging of wet tones or colors can be difficult to control. The secret is to have just the right degree of wetness so that only the edges of the appropriate areas blend, without the sudden flooding of one area into another. A useful tip is to dampen the area with clean water before blending. If the tones are then laid in with a fairly dry brush there is less chance of flooding.

The method you use will depend on whether you want smooth gradations of color and tone, a layered effect built up by overlaying colors, or an optical mixture created by massing linear pencil strokes to produce overall color blends as with hatching.

There are two basic ways of blending together different colors or tones. One is to shade areas carefully to merge them together. The other is to shade them together roughly and complete the blending by rubbing over areas to be joined. The artist here rubs over pencil shading with a torchon. This method can be particularly useful for blending small areas.

BLENDING WITH CHALKY PENCILS

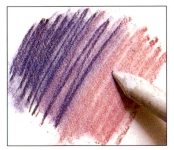

1 The texture of chalky pencils allows the colors to be blended by rubbing. You can begin by working one color over another with loose hatching.

2 Use a torchon to spread the color, and press it into the paper grain by rubbing gently but firmly over the pencil marks. Alternatively, you can rub with your fingertip or a cotton swab.

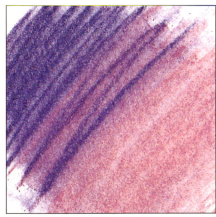

3 In this example, the blended colors still show the direction of the original hatching, creating a soft but active surface effect.

4 To blend flat color areas, begin by laying down areas of solid shading. Then, using the torchon, soften the transition from one color to another where the shaded areas come together.

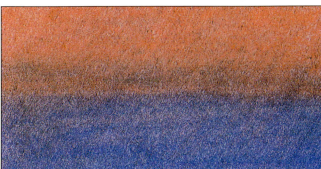

BLENDING WITH WAXY PENCILS

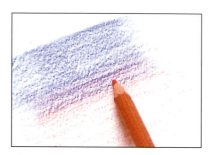

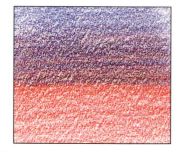

1 Waxy-textured color does not spread easily, so you need to create a blend by working one color over another. When shading, keep the pencil strokes even and work them in the same direction in each color area.

2 By overlaying the colors, you create a third color that merges the hues of the first two. You can shade lightly, as in this example, or rework the color layers until you fill the paper grain.

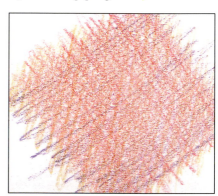

3 An alternative method of blending is to use the technique of cross-hatching. Apply a different color each time you change the direction of the sets of hatched lines.

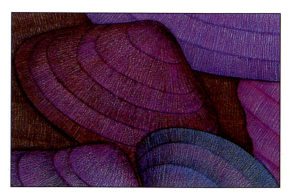

SHELL TAPESTRY (DETAIL)
BY MATHILDE DUFFY
Subtle blends in the range from red through purple to blue have been achieved here by stroking one color into another with soft shading and hatching. The pencil lines follow the directions of the shell patterns, constructing form and texture at the same time.

BLOCKING IN

The term blocking in refers to the early stages of establishing a composition in any medium. In colored pencil work, depending on the complexity of the image and the drawing style, it may involve sketching the main outlines and laying in blocks of tone and color to indicate form and volume using, for instance, light shading or hatching.

Generally, it is advisable to get a feel for the whole composition before working any single area in detail. This enables you to check that different elements of the image are in correct scale and proportion, and that the whole image area fits on the paper. However, because colored pencil work often involves delicate surface textures and a gradual build-up of detail, you must take great care not to overload the surface in the early stages, or make deeply impressed marks in the paper that will show through subsequent color layers.

The key is to keep the treatment light and open until you are satisfied with the overall effect, then you can start to develop the detail of form and color more distinctly.

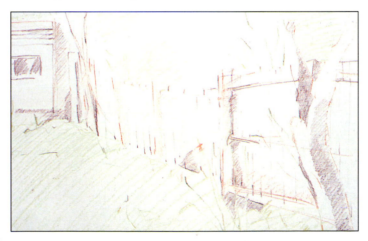

1 The first stage of this piece is the use of lightweight contour drawing to form a basic framework for the composition. The general shapes and patterns of the garden fence and trees are drawn in line. Then as the view takes shape, the main lines are given more emphasis and some soft shading is applied to indicate three–dimensional form. Only two browns and two greens have been used to identify different elements of the garden area.

2 The overall impression of shape and color is developed with hatching and shading in the same color range, keeping the pencil marks light and open.

3 Gradually the weight of the shaded areas is built up to give solidity to particular shapes. Additional linear marks are applied to sketch further detail of the trees, shed and fence.

4 The process continues in the same way, introducing more colors but keeping the texture of the drawing open and workable. It is important when blocking in not to apply shading and hatching too heavily, or you close down your options for making changes and developing detail.

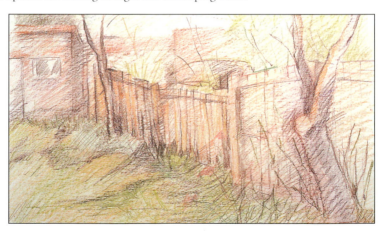

BRACELET SHADING

This method of shading uses parallel lines like hatching but the lines follow the contours of the form being drawn.

To make a line drawing of an object by just copying its silhouette can easily produce a cardboard cut-out effect. To avoid this, it is necessary to use line to describe the volume of the form, which can be done by bracelet shading. The great German draftsman Dürer (1471–1528) was one of the first to exploit this technique, although many artists since, especially engravers, have used line in this way. The shading is produced by a series of parallel lines that follow the bumps and hollows of the form being drawn. The technique is well suited to pencil, or pen and ink, but is used sometimes with pastels or charcoal.

Many sculptors have favored this technique when examining or exploring their ideas for three-dimensional work. But its name reveals its weakness. Bracelet shading can easily make the object look as if it is contained in bracelets or cut into diagrammatical cross-sections. The bracelets don't have to be this mechanical, however: the lines can swell or thin out and they can round the form at different angles, as in the expressive drawings of Henry Moore (1898–1985).

This section of a branch was rendered in charcoal. The bracelets guide the eye around the cylindrical form and also create shading to convey the effect of light – enhancing the illusion of a three-dimensional form.

Pen and ink were used to draw this branch. The underlying tubular forms and the way that they intersect are clearly described with bracelet shading. The flexible pen line also shades the forms.

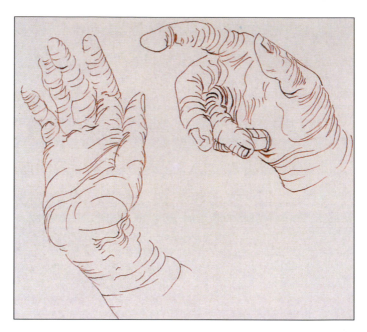

Drawing the complex forms found in the human body presents particular difficulties. Here bracelet shading conveys the three-dimensional qualities of the form, while the sepia lines suggest texture and movement.

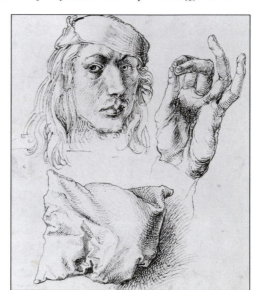

SELF-PORTRAIT
BY ALBRECHT DÜRER

Dürer drew this self-portrait at the age of 22, having already developed an individual style. Here with pen and ink, he used a combination of bracelet shading, hatching, and cross-hatching to illustrate an assured grasp of form and volume.

BURNISHING

The general definition of burnishing is applying friction and pressure to make a surface smooth or shiny. Burnishing with colored pencils creates a glazed surface effect, compacting the color and ironing out the grain. It can give the impression of colors being more smoothly blended, and increase the brightness and reflectivity of the surface.

A commonly used method of burnishing is close shading with a white pencil over colors previously laid. You need to be careful to apply firm pressure, which physically compresses the underlying pigment and paper grain. The white overlay unifies colors and tones while also heightening the surface effect. Alternatively, you can use a pale-toned pencil, a neutral gray, or one with a distinct hue of its own such as a light, cold blue or warm pale ocher. This may be better suited to the mood or material of your subject, but remember that the color you choose will modify underlying hues, and you will lose any pure white highlights unless you leave them unburnished.

Dense, waxy colored-pencil marks can also be burnished with a torchon (a rolled-paper stump) or a plastic eraser. This avoids the color changes caused by overlaying a pale tint.

Burnishing can be used to give an overall finish to a whole image or employed selectively to imitate shiny materials such as metal, glass, or smooth fabric. It can be the final stage of a colored pencil drawing, or you can rework the burnished area after spraying it lightly with fixative. The pressure you apply and the layering of colors may cause a "wax bloom" to build up on the surface, coming from deposits of the wax in the pencil lead. This can be gently wiped away with a tissue and the surface fixed to prevent the problem from happening again.

Red pencil shaded over yellow has been burnished with a white pencil. The pressure blends the colors, producing a soft hazy orange.

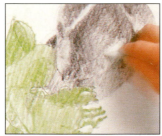

1 The subject chosen has two main colored shapes, a black hat and a green scarf. Burnishing is used to blend the tones and bring up highlights. First, the outlines are sketched in and the hat is shaded lightly with a chalky black pencil. By overlaying areas of shading, the shapes of the hat and scarf are modeled in tone. A torchon is used to burnish the colors, blending the tones to create softer gradations.

2 The light and shadow on the hat are enhanced by burnishing the highlight areas with a waxy white pencil. This merges the pencil marks, creating solid pale grays.

3 The folds of the scarf are modeled by overlaying

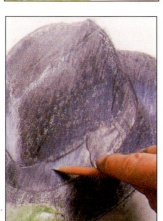

color, using a yellow wax pencil over chalky green. You can also see where white has been applied over the green in the same way as on the hat.

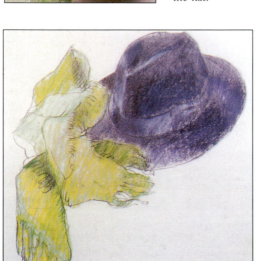

4 In the final stage, loose drawing with a graphite pencil creates texture in the folds and fringe of the scarf. Linear detail can be freely applied over burnished color, although its surface is quite compact.

COLLAGE

Drawing on a collaged surface extends the principle of working on colored papers, allowing you to use different colors and textures of paper within a single image.

Collage applies most effectively to subjects which contain distinctive forms and hard-edged shapes – it is a particularly appropriate technique for still life, architectural views and interiors, and also works well for informal portraits.

You can use papers varying from lightweight tissues to colored drawing and pastel papers. Tear or cut the papers into the required shapes, assemble them on the base paper and stick them down, then work into the image with colored pencils to develop linear structure and textural detail.

To avoid tearing, especially of fine papers, allow the adhesive to dry before you start to draw. Remember, too, that the thickness of a torn or cut edge will disrupt the path of your pencil slightly, so be careful when working on drawn details that cross between different areas of the collage.

1 The main shapes in the still life are cut out of colored papers corresponding to the basic color of each fruit. A brief outline is sketched before cutting, and the first cut shape is used to determine the scale of adjacent shapes, as here with the leafy tuft of the pineapple.

2 When all the main elements are cut out, the pieces are assembled roughly on the backing paper, to get the composition right and check the relationship of shapes. To make a dramatic image, the artist decides to use strong, solid colors to form a simple background. These geometric blocks are cut and pasted down, then the fruits are stuck on one by one to complete the still life. If you use a spray or rubber adhesive, you can lift and reposition the shapes when necessary.

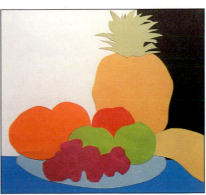

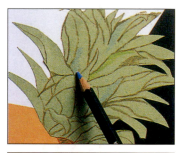

3 Allow your adhesive to dry before drawing over collage – if the paper layers are damp, the pencil point may tear the surface. The drawing begins with detail of the pineapple leaves, using line to define the intricate shapes and introducing tonal shading and color variations. The faceted texture of the pineapple skin is treated in the same way, using line work and shading to develop form and texture. Notice that you can apply colored pencil over the background if you wish, to refine the contour of the original collaged shape.

4 The paper color for the green apple is a good match for its skin color. Lightweight shading in dark green, white, and yellow is applied to model the rounded forms and bring up highlights. The red apple has more complex color variations, which are stroked in with rapid lines.

5 The drawing mainly adheres to the outlines of the collaged pieces, but contours and shadow areas drawn with dark pencil colors are used to redefine shapes when required.

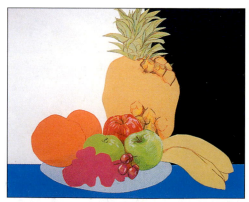

6 The process will continue until all of the fruits are drawn in detail, then any problems with the balance of color and tone can be corrected with final touches to the colored pencil drawing.

COLORED PAPERS

The small area of contact that the pencil tip has with the paper means that it can take a lot of time and effort to build up areas of solid color. Depending on the nature of your subject and the style of your drawing, working on colored paper can have distinct advantages.

The color of the ground can be used in two particular ways. Firstly, it can act as a mid-tone that enables you to key the range of tones and hues in your applied colors. Secondly, it can form a unifying element of the composition, perhaps standing for a specific element of your subject – for instance, blue for sky and seascape, green or terra cotta for a landscape, a warm beige or buff background for an interior or still life.

Colored pencils are often slightly translucent, so the paper color modifies the pencil colors, especially the lighter tints. You may wish to make a tint chart trying out the effect of colored lines and areas of shading on the ground you intend to use. This enables you to predict modifications and make use of the harmonies and contrasts that the paper color can introduce.

It is best to select low-key or neutral tones and colors – very brightly colored papers

can make it difficult to handle your range of pencil colors, although on occasions you might require a dramatic color effect to suit the mood of the subject.

If you want to include subtleties such as blended background colors or light textural effects, you can prepare a colored ground by putting a watercolor wash over stretched white paper.

There is little advantage to using a colored ground if you eventually cover it completely, so experiment with pencil techniques that give an open surface texture, allowing the paper color to contribute, such as dashes and dots or hatching.

A RANGE OF COLORED PAPERS

A colored paper will be closer to the average tone of the final picture, making it easier to key the range of tones and hues in your applied colors.

CONTOUR DRAWING

This method involves using line to describe the three-dimensional qualities of an object. The line must indicate the thickness of the form it surrounds and not simply the length and width.

When drawing a head, for example, an inexperienced artist will often use line to do two things: first to describe the extreme edge or outline of the head, known as the silhouette; second, to outline the major features within that silhouette, such as the eyes and lips. In a drawing approached like this, although all the features are indicated, to the viewer the face and head appear flat. There is no information in the drawing to tell us that a head is actually rounded, and we therefore use our own knowledge to make up the deficiency.

This is where the contour line is needed. Imagine moving your finger over the surface of a face, across the bumps and hollows. Now use a line to track the movement of this finger. The line does not just keep to the edges but goes across the forms, indicating where the surface of the object is closer to you or further away, where it is curved and where it is flat, following the sense of touch.

If you drape a piece of striped fabric and then draw it by copying the stripes and not the edges, you will see how the stripes become contour lines and create a sense of three-dimensional form; but don't put stripes around everything you draw. Contour drawings by artists such as Ingres (1780–1867) or Picasso (1881–1973) make very subtle changes in the width and weight of line so that the fullness of the forms contained within are indicated. With a subtle outline only a few contour lines are needed to suggest the third dimension.

UNTITLED BY LESLIE TAYLOR
This drawing shows an interesting combination of contour drawing and subtle shading.

MONOCHROME DRAWING

1 In contour drawing, if you are using a colored pencil in the same way that you would draw with a graphite pencil, it is best to choose a dark-toned color. The effect of, say, indigo blue or burnt umber, is softer in mood than black. This drawing begins with the outline and main features of the seated figure.

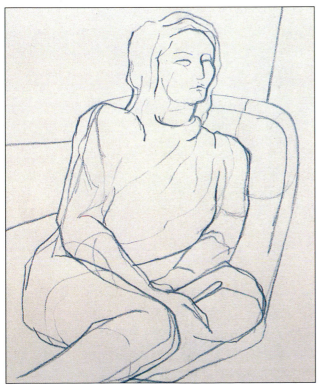

2 Although contour drawing is a minimal process, using only the linear cues in your subject, you do not have to get it all right the first time. As you retrace the contour lines that you see, the "correct" form will emerge, and you can enhance the effect by strengthening the weight of certain lines.

41

COUNTERPROOFING

This is a simple, quick technique for transferring a graphite pencil drawing from one sheet of paper to another, thus producing a lightweight, reversed image.

Counterproofing is a suitable transfer method for work to be done in watercolor and pencil, since it involves dampening the paper, which will have no ill-effect if you are transferring the drawing onto paper stretched for watercolor work.

Spray the original pencil drawing with a light haze of clean water, using a fine plant spray (it is important to moisten, not soak the paper, or it will disintegrate when you apply pressure). Lay it face down on the drawing paper and apply even pressure to the back to "print off" the image. You can do this by rubbing lightly but firmly with a soft cloth or sponge.

For other methods of laying out the guidelines of a composition, see also squaring up or down, and tracing.

1 The original drawing that you use for counterproofing should be in soft graphite pencil and should not be fixed. Use a fine-spray plant mister to dampen the surface of the drawing.

2 Lay the drawing face down on a clean sheet of paper. Rub the back and apply pressure evenly to press down the graphite lines. In this demonstration, a torchon is used to press on the back of the paper with a motion like that of shading with a pencil, but you can also rub with a soft cloth or the back of a spoon.

3 Turn back the original drawing to check that the lines have been transferred to the clean paper. You should obtain a soft, grayed line image that can be covered by the colored pencil marks. Wait for the paper to dry before starting work.

DASHES AND DOTS

Brief marks made rapidly with the point of the pencil by stroking, stabbing, and twisting the pencil tip on the paper can be used to build up color masses or to represent surface texture.

This technique is not the same as the dot technique known as stippling, which needs a fairly systematic approach if it is to work as an effective modeling method.

Depending on the quality and motion of the pencil point, you can obtain quite a fine, calligraphic effect or an active, aggressive pattern of marks. You can work over flatly shaded color areas, or build up color masses by repeatedly reworking the dash and dot patterns with different colored pencils. This is a lively, informal technique, and by experiment you will find out how it can relate to particular qualities in your drawing.

DIRECTIONAL STROKES

These loose dashes follow the natural direction of a slanted stroke drawn by a right-handed person. The pencil is used slightly blunted to make a grainy mark.

SCRIBBLED DOTS

Rough-edged, broad dots are created by moving the pencil in a brief scribbling motion, not by stabbing at the paper.

TICKS

Rapid ticks form a loose, open pattern of irregular marks. Some marks are almost straight with a slight hook; others become active zigzags.

FEATHERED STROKES

Lightweight vertical dashes merge into a soft directional pattern. The blunted pencil tip and gentle pressure create an atmospheric, grainy texture.

IRREGULAR SPACING

While applying these sideways dashes, the spacing and pressure have been varied to suggest an irregular, slightly undulating surface.

45

DRAWING INTO PAINT

The main purpose of this technique is to combine the fine linear qualities of the relatively hard pencil tip with the fluid or solid textures of brushed color.

The effect of drawing into paint varies depending on the type of paint. With thick, opaque paints such as gouache or acrylic, you can obtain a three-dimensional texture by creating grooves and ridges in the paint, at the same time depositing color from the pencil within the grooves. If you work into a thinner wash of color, the grainy texture of the line drawing contrasts with the fluid coverage of the paint.

Remember that the pencil tip creates friction on the paper. For this reason when you work into damp paint there is a risk of tearing the underlying surface. If you want to draw into watercolor or gouache washes while they are still wet, use a soft waxy colored pencil or a water-soluble one that will be slightly dissolved by the paint. (See also solvents, watercolor, and pencil.)

GOUACHE AND COLORED PENCIL

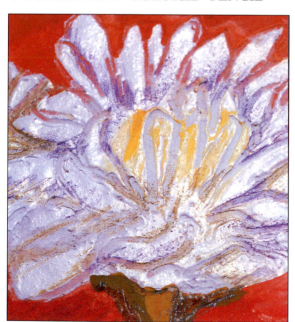

This painting began with the background wash of red gouache, leaving the shapes of the flowers roughly silhouetted on the white paper. White gouache was thickly applied to the shapes, and colored pencils were used to draw in the petals making a three-dimentional "relief" effect. Stems and leaves were drawn with a brush and green gouache, then pencils were used to shade the tones and insert linear detail.

ERASER TECHNIQUES

Using an eraser to make corrections is a limited process in colored pencil drawing.

Only lightweight strokes can be eradicated completely; a dense application typically leaves a color "stain" on the paper even after quite vigorous rubbing with an eraser, and heavy linear marks will also leave an impression in the paper surface that may show through subsequent reworkings.

The efficiency of erasures also depends on the type of eraser and the texture of the colored pencils you are using. A plastic eraser used on waxy colored pencil marks may spread the color rather than lift it –

you can use this effect positively as a means of blending colors or burnishing the surface.

An eraser may retrieve the surface sufficiently to allow you to rework the area to modify tones and hues. Where you have a thick build-up of waxy color, use the flat edge of a scalpel blade to scrape away the excess before using the eraser. If you have made a serious error in one part of the drawing at a late stage, it may be possible to insert a patch correction.

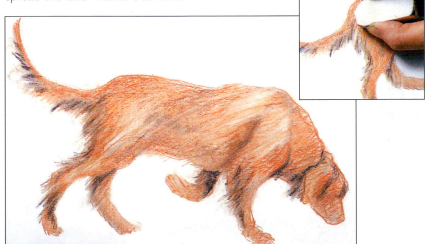

A plastic eraser was used at the contours of the animal's tail and underside to drag the color outward, making light, feathered marks corresponding to the texture of the longer fur. The eraser was also used for cleaning up the drawing and burnishing the highlight areas where the color has already been scraped back, enhancing the impression of form and texture.

FEATHERING

Feathering is a technique whereby an area of tone or color is lightly drawn over with the same or another medium so that the original area shows through.

Feathering involves making delicate diagonal hatched strokes over the underlying color, keeping the wrist loose and using the lightest touch.

It might be used to enrich a rather flat and dead passage in pastel or crayon. In a black and white drawing, white conté can be feathered over a dark area to lighten it slightly and produce a more subdued effect. Feathering is good for softening hard edges or for making transitions from light to dark. The name is derived from the fact that the overlaid color looks as if it has been brushed on with, and actually resembles, the barbs of a feather.

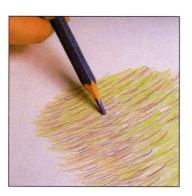

An area of short and delicate hatched strokes has been drawn with a green colored pencil. A purple pencil is then used to feather short contrasting strokes across it.

On tinted paper a delicate layer of yellow pastel strokes has been overlaid with a bright pink pastel. The artist is adding additional yellow to the area by feathering across it.

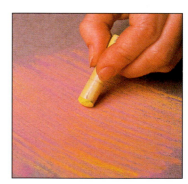

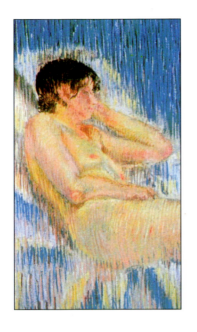

An elaborate form of feathering has been successfully employed for this pastel drawing of a nude. Broad areas of pale color were blocked in to indicate the main shapes. Once the correct proportions had been established, the artist then began to develop the color. Small vertical strokes were feathered and hatched onto the underdrawing. The detail (below) shows how the accumulation of strokes has modified the basic colors, producing subtle and subdued mixtures. Apart from the color effect, the vertical strokes provide an interesting contrast to the horizontal emphasis of the subject herself.

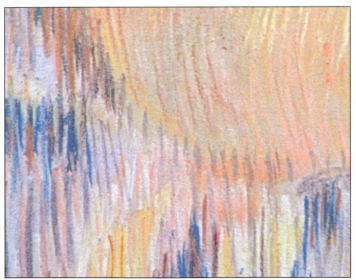

FILLING IN

Certain types of color drawing will require you to fill a hard-edged shape quite precisely with solidly shaded color. Controlling the pencil to follow an intricate outline while maintaining consistent pressure and direction in the shading is not easy, but it is a skill that comes with practice.

The method you use to color a filled shape depends on the edge quality you wish to achieve and the complexity of the color effects within the shape. If you have to turn the pencil – or the paper – to gain access to various parts of the contour, bear in mind that a change of direction in heavy shading can show up. To obtain a smooth finish, apply the shading lightly so that the directional strokes are barely perceptible, and build up the color in fine overlays.

A mask or stencil is a useful device. You can shade up to or over the edge of the masked shape, so that the direction of the strokes remains consistent. If you like the effect of a hard outline, you can use the technique of impressing to give a clearly visible contour, either in the same color that you are using for the shape or in a contrasting hue or tone.

WORKING TO AN OUTLINE

1 Trace your drawing down lightly on the paper to form a faint guideline. To create a clean, hard-edged shape, draw the outline with the color you intend using to fill it.

2 Apply solid shading within the shape, working carefully toward the outline. To fill small curves and angles, you can work the shading in different directions, but keep it dense and even to obtain a flat color area.

FREE SHADING

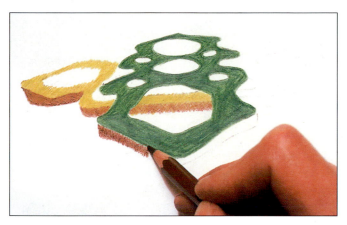

Here shapes are freely shaded to provide a soft edge. You may find it easiest to control the color area by angling the shading toward the contour lines, with strokes of even weight and length.

EDGE QUALITIES

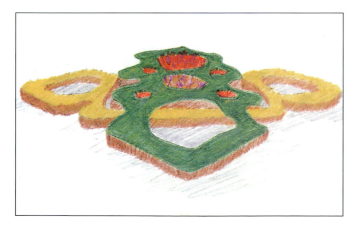

In the completed vignette, the varied edge qualities give interest to the drawing. The lighter green has been shaded over the brown to bring the colors together. Some loose color work has been applied on top with moistened watercolor pencils in red and purple, and the ground shadow is loosely shaded in gray to bleed off into the white paper.

FIXING

Fixing is by no means essential, although useful in some types of graphite and colored pencil work, but in general, the finish of a colored pencil drawing is not fragile, nor is it prone to smudging under normal handling. However, where you have a heavy build-up of soft-textured colored pencil, you may wish to apply a light spray of fixative as a finishing coat to protect the surface.

Fixative can also be applied at intermediate stages of the drawing. This sometimes makes it possible to go on working a surface that has become slightly resistant.

Spray fixatives, available in CFC-free aerosol cans, are colorless in themselves, but they can affect the colors you have laid down, sometimes darkening their tones or dulling their brilliance. You can carry out a simple test by shading blocks of color and then masking off one half while spraying fixative on the other.

APPLYING FIXATIVE

Hold the can of fixative about 12 in. (30 cm) away from the surface and spray lightly but evenly to cover the whole of the drawing. If you are using chalky pencils that deposit very loose color, you can apply a second coat, but be careful not to saturate the surface.

COLOR TESTING

1 Select the colors that you intend to use in a drawing and make blocks of shading with each one on white paper. You can use this method to test your whole range of pencils. Then place the color chart flat on your work surface and cover half of it with a clean piece of paper and apply fixative.

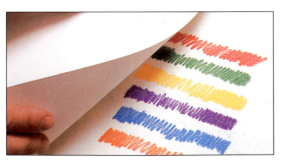

2 Pull back the covering sheet and compare the sprayed and unsprayed halves of the color blocks to see if the fixative has affected the hue or tone. In this example, there is no appreciable difference.

FROTTAGE

This technique is used in drawing to obtain textured effects.

The origin of frottage as a technique for making art is normally attributed to the German Surrealist, Max Ernst. He is reputed to have had the idea while staring at some scrubbed wooden floorboards. The prominent grain stood out like the lines in a drawing, and when he made a rubbing the inherent shapes within it inspired all kinds of images. By means of frottage, he transformed commonplace textures into drawings full of fantastic creatures, unusual forms, and foliage.

A frottage can be produced from almost any firm surface on which you can place your paper. Wooden boards, textured metal, meshes, and fabrics like hessian give good results. Most dry media are suitable for making the rubbing and soft pencils or conté crayons are particularly effective. Frottage techniques can also be used in conjunction with colored pastels to produce broken color effects.

WOOD GRAIN

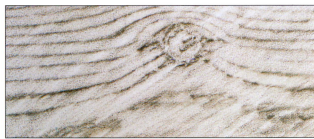

Some types of finished wood, used for shelving and furniture, for example, are too smooth to provide good surfaces for rubbing. This example comes from an old wooden plank broken off a garden fence. The knot and grain come up very clearly.

1 Paper has been laid down on the rough end-grain of a sawed tree trunk and shaded with a soft pencil to produce a textured area

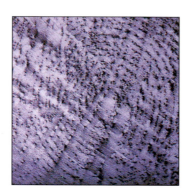

2 The growth rings of the tree are clearly visible in the completed pencil rubbing when viewed from a distance.

TEXTURED GLASS

Window glass with a lumpy, "pebble" texture produces an interestingly graphic network of color. On the other side of the glass, the swellings and hollows are reversed and the frottage forms a kind of leopard-spot pattern (center). Two colors overlaid, using the front of the glass to give the texture, create a fluid, rippling pattern of interwoven lines (below) that could form a pictorial equivalent for the surface of flowing water.

TEXTURED WALLCOVERING

This rubbing from a section of wood-grain wallpaper found in an ordinary domestic interior produces a broken, irregular texture that could be used to simulate natural weathered stone or rough concrete.

Before starting this portrait a sheet of coarse glass paper was placed beneath the drawing paper. Using a 4B pencil and firm pressure a grainy texture was imparted to the lines and patches of tone.

All sorts of surface are worth exploring to find interesting textures. Conté crayon and frottage on the reverse side of linoleum produced this example.

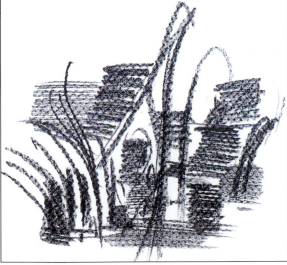

GRADATIONS

These are smooth transitions from a light to a darker tone or from one color to another.

The ability to make gradations, or smooth transitions, is most important if rounded forms are to be drawn realistically. The most complex arrangement of these forms occurs in the human figure, but vases, kitchen utensils, fruits, and vegetables – the familiar objects in a still-life drawing – all have rounded forms. When drawing landscapes the ability to re-create the forms of trees and shrubs depends on subtle tonal and color gradations. The representation of sky and sea, too, frequently requires the use of gradation.

There are various ways in which these transitions can be made. With blending techniques, for example, watercolor and ink washes can be graded by controlled addition of water onto the paper, or by blotting with absorbent tissue. Hatching can also produce gradations of color and tone, as can stippling. It is possible to produce very smooth gradations using different grades of pencil on a medium-tooth paper. With pastels, colored pencils, and conté crayons, white can be blended in to lighten a tone or color.

Colored pencils are ideal for producing gradations of color. The top strip was achieved using considerable pressure on the pencil, and the bottom strip by using very little pressure.

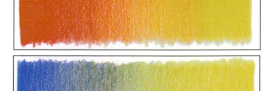

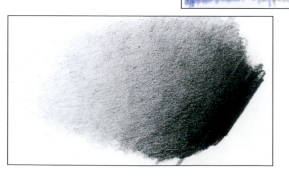

A combination of a B pencil, a 4B pencil, and vigorous rubbing with the finger has produced a smooth tonal gradation containing very delicate grays and a rich black.

COLOR GRADATION

The tonal gradation used in the previous demonstration is transformed into a delicate color gradation by laying in a lighter turquoise-blue over the pale tones of the original mid-blue, shading off on a similar scale of density.

A gradation through three colors is expertly controlled to avoid the effect of a hard line at the junction of the color areas. This technique is only mastered with practice, during which you learn to lighten up the shading by just the right amount, then work in the next color seamlessly.

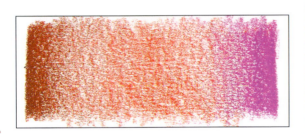

TONAL GRADATION

A very subtle transition through graded tones of one color is achieved by shading carefully with the pencil and gradually decreasing the pressure to lighten the tone. It requires careful handling to avoid abrupt changes that would produce the effect of successive color bands.

Shaded gradation is the classic method of modeling form with pencils. In this example, the overall tone is quite dark, but there is a smaller area of mid-tone surrounding the white highlight.

HATCHING AND CROSS-HATCHING

Pencil is naturally a line medium, although there are many ways of building up areas of solid and mixed color. Hatching and cross-hatching are traditional methods of creating effects of continuous tone using linear marks. With a color medium, they can also be a means of integrating two or more hues and producing color changes within a given area.

HATCHING

Hatching simply consists of roughly parallel lines, which may be spaced closely or widely, and with even or irregular spacing. In monochrome drawing, the black lines and white spaces read from a distance as gray – a dark gray if the lines are thick and closely spaced, a pale tone if the hatching is finer and more open. The effect is similar with colored lines, the overall effect being an interaction between the lines and the paper color showing through.

The technique of hatching can be clean and systematic, or free and variable. The lines can be of relatively equal weight and

spacing, or may vary from thick to thin, with gradually increased or decreased spacing.

Formal hatching consisting of strictly parallel lines, can be drawn using a ruler. Left shows different densities of ruled black lines. A ruler was also used for the middle example, but this time employing different-colored pencils with a black line interspersed between them at the bottom. On the right, the softer colored lines are produced by felt tip pens, enabling bands of color to be subtly modulated.

VARYING THE TEXTURE

Different qualities of tone and texture are developed by varying line weight and spacing, and by combining colors. Lines that are converging rather than parallel suggest space.

FREE HATCHING

The lines of hatching do not have to be distinct and separate. Here the second layer of color is hatched over the first with a free scribbling motion.

CROSS–HATCHING

Cross-hatching is an extension of hatching in which sets of lines are hatched one over another in different directions, producing a mesh-like or "basketwork" texture. Again, an area of dense cross-hatching can read as a continuous tone or color. However, both techniques bring an additional dimension to the drawing. The direction of the lines can be manipulated to describe form and volume; the textures of hatching and cross-hatching produce a more lively surface effect than solid blocks of tone or color, while still constructing coherent shapes and masses.

The effects of these techniques vary according to the character of the lines you draw, their spacing and direction, and the interaction of hues and tones. With practice, you will discover how these elements can be applied to describing specific aspects of form and space, local color, and qualities of light and shadow in a composition.

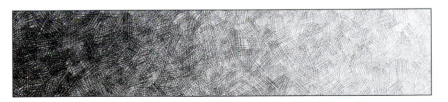

This cross-hatched tonal scale indicates the degree of nuance that can be achieved with the technique. Despite the fact that the only medium used was a black pen, variety and gradations in tone were accomplished by varying the line density and the amount of pressure applied.

CONSTRUCTING FORM

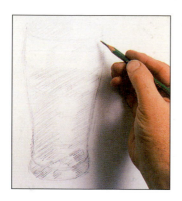

1 To model a form with hatching and cross-hatching, you need to begin with a clear impression of the shapes and tones in your subject. This drawing starts with a pencil outline and lightly hatched indication of light and shade.

2 The mid and dark tones are developed with black and blue pencils. When you are working on fine hatching, the pencil needs to be kept quite sharp to maintain an even line quality.

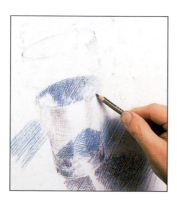

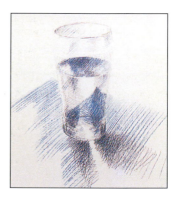

3 With the introduction of a lighter blue and the gradual build-up of the darkly cross-hatched areas, the drawing takes on a definite impression of three-dimensional form.

4 The tonal structure is continually intensified, keeping to the basic monochromatic palette. The different densities of the hatching and cross-hatching divide the overall shapes into distinct areas of light and shadow, describing the glass, the flat tabletop and the effects of transmitted and reflected light.

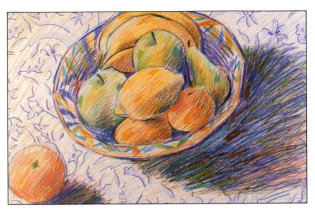

FRUIT BOWL

BY Sara Hayward

The combination of hatched and shaded color creates an open surface texture that allows the colors to sing out clearly. Notice that the heavy shadow areas are also treated colorfully.

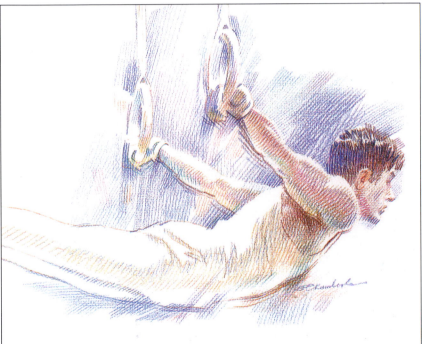

GYMNAST BY John Chamberlain

A very free use of these linear techniques is cleverly controlled to model the gymnast's body quite precisely. The heavily grained paper enhances the patterned effect of hatching and cross-hatching, but the arrangement of line and color makes a solidly descriptive image.

HIGHLIGHTING

A highlight is the brightest point of reflected light in an image, typically represented in drawing and painting as a flash, spot, or patch of pure white.

Because of the translucency of colored pencil leads, it is difficult to obtain a clean effect by applying white highlights as finishing touches, as you can with an opaque medium such as pastel, gouache, or oil paint.

There are methods of creating highlights that rely on allowing the white of the paper to show through the color – leaving the paper bare so that the highlight is a distinct white shape, or erasing the color to retrieve the paper surface. Erasure only works well if the color application is light and the paper surface quite resilient. The technique of impressing can be effectively applied to creating fine linear or dot highlights.

If you are working on colored paper, you can apply bright highlights with a white pencil directly on the paper surface – if the pencil is fairly

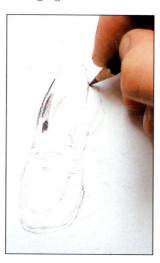

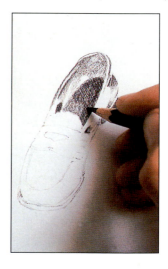

1 When you are planning to create highlights by leaving the white of the paper bare, you must achieve a clear "map" of your subject before you start shading. Make a light outline drawing that locates the important shapes.

2 Shade in the color slowly, working up to and around the highlight areas. Take special care when dealing with fine detail, such as the linear highlights on the heel of this shoe.

soft-textured and the paper color not too intense, you should obtain a clean white. If you do not need to impose highlighting over densely worked colored pencil drawing, you can add opaque color in the final stage using pastel or paint, being careful to create marks of suitable scale and texture to integrate with the colored pencil strokes.

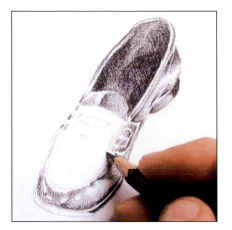

3 Build the tones gradually, keeping the contrast of lights and darks. Try to hold your hand clear of the drawing, to avoid smudging color into the white areas. When you are working on a broader composition, use a clean sheet of paper to protect the area beneath your hand.

4 The finished drawing gives an effective impression of the shiny leather, by forming an appropriate contrast of the lightest and darkest tones, and leaving soft but clean edges to the highlights.

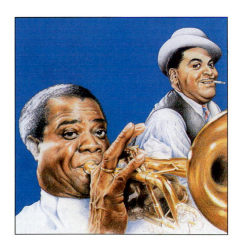

LOUIS ARMSTRONG AND FATS WALLER BY JO DENNIS
Very strong highlights give a heightened sense of realism to a naturalistic rendering and make the image sparkle. To obtain clean whites, make sure the paper surface remains untouched in highlight areas, or paint them in at the last stage with opaque white gouache.

IMPRESSING

The basic principle of impressing is that of making a mark that actually indents or grooves the surface of the paper. You can then work over it with gentle pencil shading that glides across the impressed mark, so that it remains visible through the colored overlay.

Place a sheet of paper over a soft surface such as a rubber mat or folded sheets of newspaper and draw on it using a blunt stylus. A nail with the point filed down and rounded could be used or, alternatively, the end of a small paintbrush handle. The stylus needs to be sharp enough to make an impression in the paper but not so sharp that it tears it. A more manageable tool in hardwood or metal could be made if this technique was to be used extensively.

After making this invisible drawing,

IMPRESSED COLOR LINE

1 Make a drawing of your subject with firm, even contour lines, pressing the tip of the pencil hard into the paper. Layers of newspaper placed underneath help to create the necessary "give" in the paper surface.

2 Shade lightly over the drawing, allowing the pencil tip to skip over the impressed lines. You will see that the original lines read clearly through the overlaid color. You can use more than one color for both the outline drawing and the shading, to form a more complex image.

lightly shade over the paper's surface with, for example, charcoal, crayon, or chalk. The impression in the paper will remain untouched and appears as a white line through the applied tone or color. If you substitute a tinted paper, a colored line will result. Powdered graphite, charcoal, or pigment can also be rubbed across the surface, or ink applied using a hard roller.

BLIND IMPRESSING

1 Make your initial drawing on tracing or thin layout paper. Place a clean sheet of drawing paper on newspaper and lay the tracing over it. Retrace the outlines very firmly with a sharp pencil point or ballpoint pen.

2 Lift the tracing paper from one corner to check that the line is distinctly impressed on the drawing paper. Be careful to keep one edge of the tracing in place, so it goes back in precisely the same position.

3 When the impressing is complete, remove the tracing and put the paper on a drawing board or other suitable work surface. Shade color over the impressed lines, using a light even motion. You can blend or overlay colors in different areas of the drawing. Be careful not to apply so much pressure that the pencil tip is pushed into the white lines.

LINEAR MARKS

Because pencil is a point medium, the kind of marks you make with it are basically linear in character.

Standard techniques of pencil drawing employ linear marks – for instance, hatching – but the tool is capable of making many different kinds of marks, which are less easily defined. These vary according to the way you push or pull the pencil across the paper as well as to whether the pencil tip is sharp or blunt, chisel-edged, or rounded. You can produce finely "spattered" slashes and trails, decisive hooks and ticks, curling flourishes or angry scribbles, linear patterns that are loose and randomly formed, or neat and regimented.

Through experiment you can build a repertoire of linear marks that may stand for different elements of your subjects – such as man-made or natural patterns and textures or atmospheric effects – and also enliven the surface qualities of your drawing. In this way you can introduce discreet variety even in areas that from normal viewing distance, read as continuous flat color or tone.

Broken shading

Flourished movement

Slanted scribble

Random scribble

Playful freehand curves

Calligraphic sequence

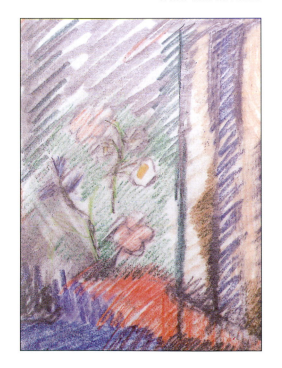

Whole hand movement

LINEAR TEXTURE

Different qualities of linear marks help to build an active impression of form, texture, and pattern.

LINE QUALITIES

The quality of line refers not to the gestural energy that you give to the pencil strokes, as with linear marks, but to the innate character of an individual line.

Four basic line qualities are usually recognized: a sharp, clean line of unvarying width implying firm contour of geometric precision; calligraphic line, tapering and swelling with a directional rhythm to show movement and energy; broken line, appearing variable and hesitant, sometimes actually fractured; repetitive line – quickly formed, parallel or overlapping strokes eventually tracing a continuous contour.

The linear bias of pencil drawing makes these qualities an important factor in determining the expressive character of an image, especially crucial when exploited in techniques such as contour drawing and hatching. Examples of three of these are shown here.

FIRM, UNVARIABLE LINE

Because of the "giving" texture of colored pencil, a line of even weight and density has a sympathetic quality, but provides a strong graphic contour.

CALLIGRAPHIC, DIRECTIONAL LINE

Variations in weight and emphasis help to model form in contour drawing.

REPETITIVE LINE

The retraced contour has the practical advantage of enabling you to modify the shapes you are drawing, and suggests the quality of movement in the subject.

HORSE AND RIDER BY
FRANK DE BROUWER
The gestures of the artists hand and arm can be seen from the rhythms of this drawing, giving it a sense of physical movement in addition to that implied by the subject. The variations of line — emphatic black colored pencil over more tenative, shifting graphite pencil marks — enhance the vitality. The non-naturalistic primary colors that provide the mid-tones between black and white are also enlivening. As well as line qualities, the artist also uses the techniques of contour drawing and linear marks.

MASKING

A mask is anything that protects the surface of your drawing and prevents color from being applied to a specific area

The simplest form of mask is a piece of paper laid on your drawing paper. The pencil can travel up to or over the edge of the paper, and when you lift the mask, the color area has a clean, straight edge. You can obtain hard edges using cut paper, while torn paper makes a softer edge quality. You can also use thin cardboard, or pre-cut plastic templates such as stencils and French curves.

If it is important to mask off a specific shape or outline, which may be irregular or intricate, you can use a low-tack transparent masking film which adheres to the paper while you work, but lifts cleanly afterward without tearing the surface. You lay a sheet of masking film over the whole image area and cut out the required shape with a fine scalpel blade. Carefully handled, the blade does not mark the paper beneath. Low-tack masking tapes can also be used to outline shapes; they are available in a range of widths, and the narrower ones are very flexible for masking curves.

LOOSE MASKING

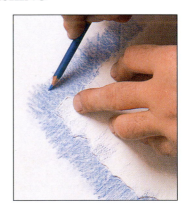

1 Place the paper mask on the drawing paper and hold it down firmly. Begin by shading lightly over the edges of the mask.

2 Build up the shaded color to the required density, keeping the direction of the pencil marks consistent at each side of the mask.

*Cut paper edge
– close shading*

3 Lift the top corner of the mask to check that you have a clean edge quality and the right intensity of color. Keep the lower edge of the mask in place, so you can just drop it back if you need to rework the color area.

USING MASKING TAPE

*Cut paper edge
– hatching*

1 Lay down the masking tape evenly but do not rub too firmly, or you may have trouble lifting it without damaging the paper surface. Shade color over the edges of the tape, as with the paper masks. An advantage of masking tape is that you can work over both sides of the tape at once if required. When complete, peel back the tape carefully.

2 If you are overlaying colors, you can use the same mask or a fresh piece of tape to cover the paper while you lay in the second color.

MIXING PENCILS

The many good-quality brands of colored pencils now available offer widely varied properties of color and texture.

There are two main advantages to building up a stock of different types of pencils. One is that you can utilize their different qualities of line and massed texture to create interesting variations in the surface qualities of an image. The other is more basic and practical – it is simply that you may find particular colors in one brand that are not available in another.

There is no formal technique governing a combination of pencil types. You need to experiment with the textures of hard or soft pencils, waxy or chalky leads, thin or thick points, and pressure variations. The weight, surface texture and color of your paper is also influential. The effects of mixing different types of pencils may be quite subtle and discreet, but this is appropriate since the scale and detail of colored pencil work often requires close attention from the viewer.

Different pencils have different qualities. Shown from left to right: hard watercolor pencil; chalky pencil; hard pencil; waxy pencil.

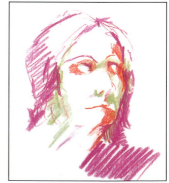

1 The reference for this drawing is a photograph with a soft, shadowy mood. The initial layers are laid in with chalky pencils to create broad, grainy lines, and gentle shading.

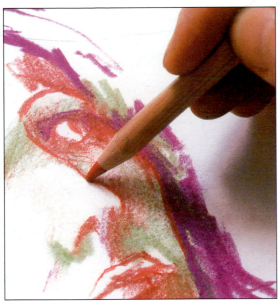

2 The lines and features of the face are sharpened using waxy pencils to create a harder line quality contrasting with the chalky marks.

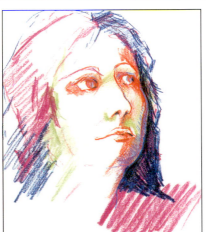

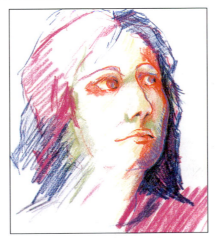

3 Soft-grade waxy pencils are chosen for applying highlighting and shadow to the face and hair. Their texture enables colors to be overlaid cleanly.

4 The linear structure is enhanced with a slightly harder type of moderately waxy pencil, with the same texture used to highlight the face in yellow. The chalk pencils are again applied, to soften the drawing in places.

OVERLAYING COLORS

The majority of colored pencil renderings depend upon the effects of overlaying colors. In this way you can achieve richness of hue, tonal density, and contrast, and effective three-dimensional modeling of forms and surface textures.

Because colored pencil marks have a degree of translucency, with the color application reflecting the influence of the paper's grain and surface finish, the process of building up a drawing in layers creates potential for many subtle variations of hue, tone, and texture.

There are many different ways of overlaying colors: you can put one layer of shading over another to modify colors and produce interesting mixtures and gradations; you can integrate lines, dashes, and dots to develop complex effects of optical mixing; you can enliven areas of flat color by overlaying a linear pattern or broken texture that subtly meshes with the original hue.

Color layering provides greater depth and detail in a composition – for instance you can achieve active color qualities in highlight areas or dark shadows, which intensify effects of light and atmosphere. In a practical sense, overlaying colors is equivalent to mixing paints in a palette – if you don't have the precise hue that you need, you can create it from a blend of two or more colors.

BUILDING UP COLOR SHADING

1 This portrait drawing begins with the face blocked in lightly with two shades of red-brown.

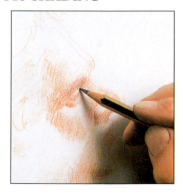

2 To enhance the modeling of the features, a dark brown pencil is used to work over the lighter color around the eyes, nose, and chin.

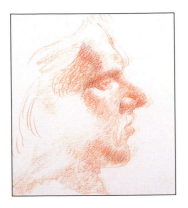

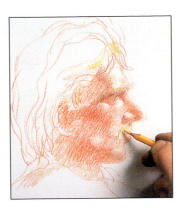

3 Even with this limited palette of colors, the structure of the face is quite clearly defined by the layers of shading.

4 Further layers of red-brown build up the contours of the face and increase the contrast of light and shadow. Light yellow is laid over the darker tones around the eyes and mouth to intensify highlighting.

MIXED HUES

Overlaid patches of grainy shading produce subtle mixtures and gradations of color. This sample contains four colors – yellow, yellow ocher, green, and gray-blue.

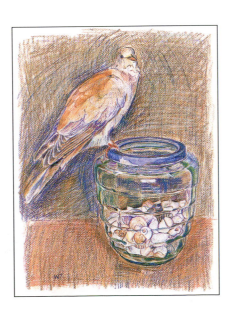

STILL LIFE WITH BIRD BY WILL TOPLEY
This interesting drawing shows color overlays built up with loose hatching and shading. The heavy grain of the paper contributes an open, free quality to the color mixes, but the layering of colors makes an attractively descriptive image conveying different kinds of textural detail.

75

PAPER GRAIN EFFECTS

To build up the color density in a colored pencil drawing, you need a surface with sufficient tooth to create some friction with the pencil point — otherwise the texture of the pencil lead rapidly produces a smooth, compacted finish that resists further applications.

The degree of tooth in a drawing paper depends on the papermaking ingredients and the method of finishing. Drawing paper, for instance, is relatively smooth, although it has an excellent tooth for pencil drawing. Pastel papers have pronounced grain intended to grip the loose pigment particles laid down by soft pastels. Watercolor papers come in a variety of weights and finishes, the heaviest having a visibly "pitted" surface texture.

The more heavily textured the paper grain, the longer the surface stays open and workable, an important consideration if you are depending on color overlays for your effect. However, on very grainy paper, it is difficult to get a fine sharp line, because the surface breaks up

the pencil mark, and tiny glints of the paper color will show through even densely worked areas of shading. Varying the kind of paper that you use can bring an extra dimension to your work. Try different weights and textures to find out if they are comfortable to work on and produce qualities that suit your own technique and drawing style.

TEXTURED PAPERS
Smooth, laid and heavily textured papers — whatever you choose will affect the quality of your drawing.

DRAWING PAPER
A relatively smooth surface with a slight tooth, like ordinary drawing paper, gives a soft grainy quality to light pencil strokes, but as the pressure of the pencil increases, the grain of the paper is likely to be "ironed out" and has less effect.

PASTEL PAPER
Papers made specially for work in pastel have quite a pronounced grain intended to grip the loose color. With colored pencils, the grain shows up as a lightly pitted pattern within the colored strokes.

Drawing paper

Pastel paper

Watercolor paper

Colored paper

WATERCOLOR PAPERS

Heavy watercolor papers sometimes prove too resistant for colored pencils. The more giving types still have a distinctive grain pattern that leaves white flecks showing through the color. The grain may be heavy, roughening the pencil texture, or it may have a mechanical pattern that breaks the marks into a mesh-like texture.

COLORED PAPERS

There are many types of colored papers and the kind that you choose depends on how much you want the paper color to influence the applied pencil colors. The heavier the grain, the more of the paper color shows through. A medium-toothed, fairly even-surfaced paper, like this black sheet, gives the pencil marks a pleasing soft texture but allows the colors to build up cleanly.

SHADING

Shading refers to the tonal elements in a drawing rather than the linear ones.

Wherever light falls on an object, you need shading to indicate areas of tone, representing the parts of the subject in shadow, and to give them solid form. Although shading can be done successfully with hatching or cross-hatching, less linear methods of applying tone are often preferred.

Pencils or charcoal sticks can be used on their sides to produce solid patches of tone. Sensitive shading with continuous tones does more than simply define the shape of an object – it can also create the illusion of three-dimensional reality, fooling the eye completely.

LIGHTWEIGHT, EVEN SHADING

Light pressure on the pencil tip enables you to build up shaded color with no linear bias. You can gradually increase the color intensity by reworking the same area.

HEAVY, DIRECTIONAL SHADING

When you put a lot of pressure on the pencil tip, the shaded area naturally forms a directional emphasis following the path of the pencil. The color effect is also more intense.

OPEN SHADING

A loose movement from the wrist, allowing your whole hand rather than your fingers to guide the pencil, produces an open, scribbled effect comparable to free hatching.

COMBINING DIFFERENT QUALITIES

When you juxtapose areas of shading of different densities and directional emphasis, the drawing begins to suggest different levels of surface planes, creating space and form.

SHADED GRADATIONS

Shading is the classic method of creating smooth gradations of tone and color. It also provides different edge qualities, depending on the direction of the marks and the eventual solidity of the shaded area.

SHADING WITH CONTÉ CRAYON

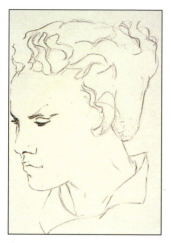

1 After the main outline of the portrait had been sketched on cream paper, a black conté crayon was used to establish the main features.

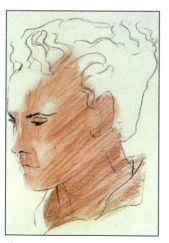

2 Using a red-brown conté crayon the basic areas of tone were shaded in. These hatched lines establish the main planes of the face.

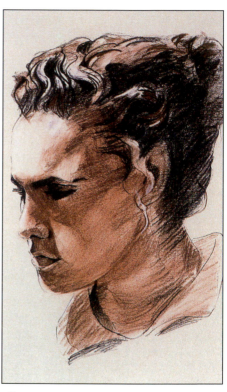

3 The shading is then strengthened with black conté crayon. Rubbing with the finger and hatched strokes produce carefully graded tones.

SGRAFFITO

The technique of sgraffito involves scratching into a layer of color to reveal the underlying surface.

In effect, sgraffito is a "negative" drawing process, as you create linear structures and surface textures by removing color, rather than by applying it.

To achieve the effect with colored pencils, you first lay down a solid block of color by shading heavily with the tip of the pencil. You then apply a second layer of a different color over the top, again built up solidly so that it covers the lower layer uniformly. The sgraffito drawing can be done with a stylus, or with the point or edge of a craft-knife blade.

An alternative method is to shade pencil color over a thick ground previously applied to the paper. An emulsion primer or gesso base can be applied to paper or cardboard as the ground for the sgraffito. (As this dampens paper and may cause it to buckle, it is advisable to stretch it first.) This technique can be used in a similar way to scraperboard to etch a white image through a dark color, or you can overlay a contrasting color.

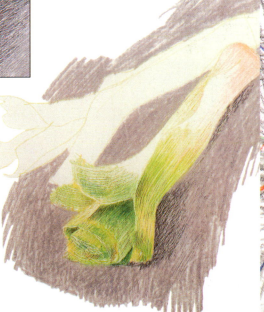

The technique is best suited to a subject that has a distinctive linear framework or texture. In this example, the sgraffito has been used to model both the rolled layers of the leek and the veiny texture of the leaves (see detail above).

SKETCHING

Sketching is usually associated with rapid drawings made outdoors, or with other studies done at great speed that are intended to serve as a preliminary to the final piece.

Sketches are sometimes called "working drawings" because they are part of the working process involved in making a piece of sculpture or a painting. At one time, sketches like this were not thought of as having any great value beyond their preparatory function, and once the painting or sculpture was finished, they were thrown away.

Sketches, then, are not usually intended as exhibitable drawings because they are often only basic or experimental ideas. Nevertheless, since the great draftsmen of the Renaissance, the sketch has been more highly valued as a work of art in its own right, revealing as it does the artist's genius most directly.

Artists often employ "shorthand methods" for including information in their sketchbooks when there may

Drawing a moving figure requires a responsive medium that will perform quickly and expressively. Pen and ink has been used to make these two lively sketches. Many artists use books like this to "warm up" before carrying out a more studied drawing. Because of their private nature, sketchbooks will often reveal an artist's more uninhibited drawings, in terms of both style and content.

This open sketchbook reveals a number of lively pencil sketches of a violinist. The shape and position of the head and the changing facial expressions have been studied quickly, using contour lines and hatched shading. On the right-hand page of the open book, the musician's head is related to the position of the violin and his torso, suggested with rapid outlines.

not be enough time to record in full. This may occur when you are working in a crowded street, a restaurant, or in a landscape where the weather conditions keep the scene constantly changing. Written notes might be added to describe colors or tones that will be needed to complete the drawing or painting later. Inexpensive books can be bought for sketching; some are spiral bound but the most practical have a sewn binding and a rigid cover. They can be carried around easily and become valuable stores of visual information and ideas for reference. The English painter Hogarth (1697–1764) once reputedly drew a scene on his thumbnail because he did not have any paper with him when he needed it. Ever since then, any small rapid drawing done to record the basics of a subject has been called a "thumbnail sketch."

Sketchbooks can easily be smuggled into places where a large drawing board or easel would be either impractical or not allowed. What better opportunity to sit and draw than on a long bus journey? Pencil was used to delineate the shapes and produce the smooth tones of this drawing.

DEVELOPING THE SKETCH

1 The artist begins a drawing of a building, having first decided on a particular viewpoint.

2 He establishes the main vertical and horizontal elements in the drawing first.

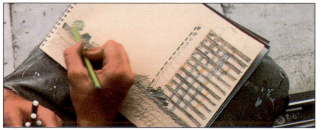

3 Local color is added with colored pencils.

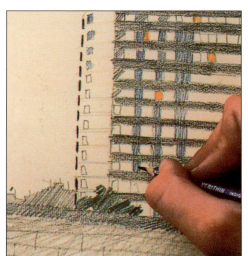

4 The building appears to be more solid as the drawing develops tonally.

SOLDIERS

BY LINDA KITSON

Colored pencils are the ideal medium for this figure sketch, capturing the poses of the men and the different aspects of their military uniforms. The artist has handled the pencils quickly and confidently, recording the telling details of form and texture.

CLOTHES PEGS BY JOHN TOWNEND

The artist's eye was caught by a view from the kitchen window, with clothes hung out to dry swaying on the washing line. The attractive feature of the colored pegs suggested the treatment, using a restrained approach to the surrounding colors and emphasizing the linear pattern in the view, while marking the dancing shapes of the pegs in vibrant hues.

SOLVENTS

The marks made with some types of colored pencil can be spread and blended with solvents — water, turpentine, or the spirit-based medium in a colorless marker blender.

Only pencils formulated to be water-soluble will react with water. Spirit solvents may dissolve the colors of pencils intended to be used dry — this has to be a matter of experiment, as it depends on the proportions of pigment and binding materials in the pencil lead, and effects are not wholly predictable.

There are two methods which enable you to take advantage of the more fluid textures produced by solvent techniques. You can either dip the tip of the pencil into the solvent, so that the color becomes softened, and spreads as you lay it down; or you can shade or hatch with the dry pencil tip, then work into the color area with solvent using a brush, torchon, or cotton swab — or with a marker blender, which is simply a marker pen that contains colorless solvent. You can combine the effects of wet and dry color by allowing the dampened marks to dry, then reworking the area with the pencil points.

USING SPIRIT SOLVENT

1 The shapes of the flowers are rapidly sketched with a soft waxy pencil line. A rag dampened with white spirit is used to spread the color delicately, indicating the areas of darkest tone.

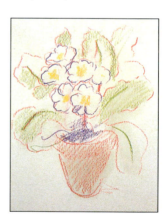

2 The line drawing is strengthened and some broad color areas blocked in with light shading. Notice the heavy grain of the watercolor paper — when applying spirit solvent, you need to use good-quality paper to avoid buckling or tearing.

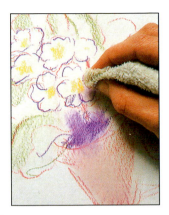

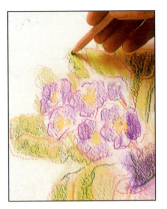

3 A second stage of rubbing with white spirit softens the color and spreads it into the paper grain. The pencil marks are just moistened, not flooded with the solvent.

4 To develop the intensity of color, pencils are used again to shade in the solid shapes. The moisture from the underlayers makes the pencil marks smoother and stronger.

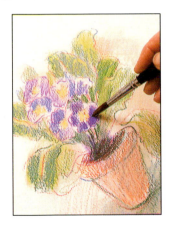

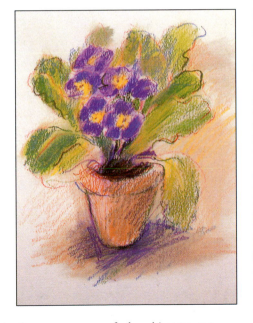

5 Applying solvent with a brush makes the color dissolve and spread more like paint. It is possible to do this selectively, to build up a contrast of different textures.

6 In the finished vignette, the brushed color comes up very fresh and intense, contrasting nicely with the more open surface qualities of the pencil shading and line work.

SQUARING UP OR DOWN

Sometimes it is necessary to enlarge or reduce a drawing, and squaring up or down is the easiest way to do this accurately.

Many artists work from photographs, not only for the convenience of being able to tackle outdoor subjects without having to work on location, but also because the limitations of photography – the way the camera reads an image selectively – can create dramatic and unusual compositions containing special qualities of light, color, and surface texture.

When using either reference photographs or sketches you may need to enlarge the image, and it can be difficult to scale up accurately working freehand. The method of squaring up or down on a grid helps you to locate the various elements of the composition.

First draw a pencil grid over the original image and then mark up a similar grid on your drawing paper but with each square proportionately larger or smaller – for instance, one and half or twice the size of the original to enlarge, or half the size to reduce. Now work across the grid square by square, copying the main lines and shapes within each section, and taking careful note of where each element in the photograph intersects a line on the grid. This simple method provides an outline drawing in proportion to the original, but because it is not strictly mechanical, you do have scope to adjust elements of the composition if you wish.

Alternatively, if your drawing is not too large, make a photocopy of it and draw the grid onto the copy, so preserving your original intact. Another method that will avoid damaging the earlier drawing is to use a clear perspex (acrylic) sheet on which the grid is drawn with a suitable felt pen or wax crayon. This grid can be placed over the original drawing, which is then transferred to a larger or smaller version.

SQUARING UP

1 With a permanent marker pen, the artist draws a grid onto a sheet of acetate. The grid is traced from a sheet of graph paper underneath, which not only saves time but also is very accurate.

2 In the next stage, a pencil, T square and ruler are the necessary tools for drawing a grid of larger squares onto the paper. The lines should be only just visible.

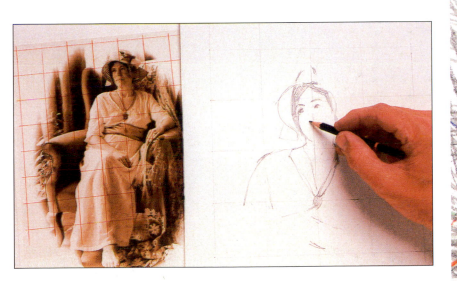

3 Finally, the transparent grid is placed over the photograph to be transferred. With a pencil the artist copies the image square by square onto his drawing paper. The larger squares of the drawing sheet serve to enlarge the original image.

TRACING

We have all used this method of transferring an image from one source to another, and it is still probably the simplest and cheapest.

With some types of pencil drawing, it is important to have a clear, accurate guideline. Extensive corrections and erasures can spoil the paper surface before you begin the tone or color work, so to avoid this you may wish to produce a working drawing paper with no alterations. Similarly, you may wish to trace off the outlines from a photograph as the basis of your composition.

1 If possible, anchor the original picture to a solid surface with masking tape. Now lay tracing paper on top and secure it with masking tape at three corners. Trace over the image in pencil.

2 Once the tracing is complete, remove the tracing paper. Now, on the reverse side, using a soft pencil, scribble roughly all over the image area.

3 To make sure the whole area is covered with graphite, use a paper towel to smudge the pencil on the reverse side and fill any gaps.

4 Turning the tracing paper onto the right side, lay it on the new paper surface, anchoring it firmly again on three corners with masking tape. Retrace the image with a sharp pencil following your original. Use a ruler, if necessary, for any straight lines.

WHITE LINE

White line, or impressing, allows you to create an image using a white line against a dark background.

The impressions or "white lines" can be impressed straight into the paper using a stylus or blunt paintbrush handle, "drawing" the lines into the paper. Color added over these impressed lines will leave them as white. The following technique allows you to follow an initial sketch.

1 First, the sketch is drawn on layout paper with a light line.

2 Place the drawing over a piece of rough textured paper, placed on a soft surface such as layers of newspaper. Retrace the image using a pencil.

3 Remove the layout to reveal the image impressed in the paper. If not pressed hard enough, the white lines will not appear clearly when the color is added.

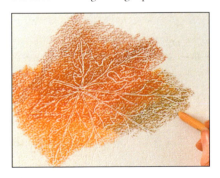

4 Apply the shading with a colored pencil. For a soft effect, rub the point down to create a flat section as this will give a more even tone.

MIXED MEDIA

Using more than one medium in a drawing does not stop with line and wash.
Any or all the drawing media can be used in the same drawing.

Using mixed media, a landscape may be swiftly blocked in with a wash of ink and the main elements drawn in using a pen. Foliage might be introduced using chalk, crayon, or charcoal and highlights picked out in white gouache.

If dark washes are applied over a colored oil pastel or wax crayon drawing, the crayon line repels the wash and stands out clearly through it. Other media such as colored pencils or felt pens can be added once the wash has dried.

By using the technique of collage, even more unusual effects can be created. Collage involves sticking materials such as paper, fabric, other drawings, or photographs onto your work. Once glued down you can draw into or add color to them. There is a vast range of media and techniques that can be included in one drawing. The only major limitation is the artist's ability to control them. He must ensure that they work together to create a unified result, rather than become a series of pictorial incidents that merely reflect technical skill.

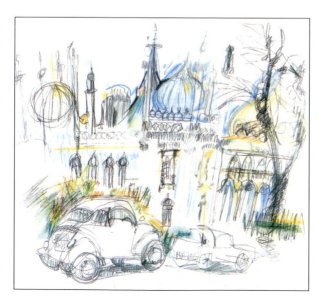

PAVILION
BY KAYLE SONG TEALE
A quirky interpretation of the perspective enhances the decorative complexity of the architecture, giving charming character to the artist's impression. Here the artist has used both graphite and colored pencils. The linear qualities of the pencil marks have been given free reign.

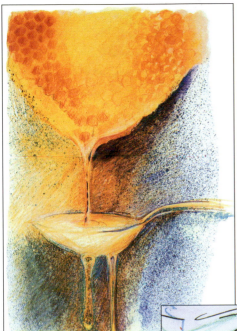

HONEY BY JANE STROTHER
The luscious subject is matched by an especially rich and inventive drawing technique. A mottled texture is created by spattering colored inks from the bristles of a toothbrush onto flat washes of color. The ink is used like watercolor, to establish a ground of bright, translucent color. Details of form, light, and shadow are drawn over the top with colored pencils.

WINTER MORNING
BY FRANK AUERBACH
The starkness of a winter cityscape is vigorously attacked with ink and pencil, making active use of varied line qualities in both media.

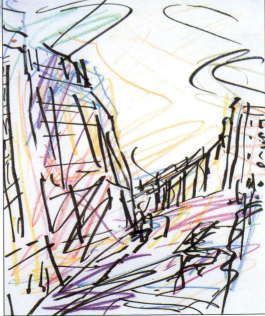

GRAPHITE AND COLORED PENCIL

Graphite pencils and colored pencils are natural partners, since they are drawing tools of exactly the same shape which are handled in the same ways.

Every artist finds different values in exploiting mixed-media techniques for particular purposes. A technical advantage of incorporating graphite with colored pencils is the range in quality of graphite leads – you can obtain varied characteristics from the fine silvery grays of H and HB pencils to the increasingly strong, intense blacks of the softer B series. Because graphite is a slightly greasy substance, and more gritty than colored pencil leads, it gives a different kind of line quality, and the dark tones are not the same as those produced by colored pencils containing black pigments.

You can either mix the two kinds of pencils freely or use the graphite to create a monochrome drawing that you then "glaze" over with color by shading in colored pencil. Both media are highly responsive to both delicate and vigorous handling, and are easily applied to a wide variety of paper types.

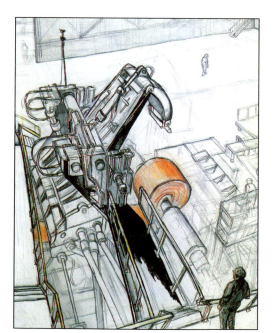

BRITISH STEEL
BY PHILIP STANTON
In this drawing, the artist has used graphite pencil to sketch out the complex framework of the composition and establish the relationship of forms. The tones and linear detail have been strengthened with black pencil, and colors have been introduced when appropriate. When a subject presents a difficult perspective or elaborate structure, as in this example, using graphite pencil enables you to draw freely, and erase and correct before you apply color. Also the graphite lines contribute lively calligraphic styling and textural contrasts.

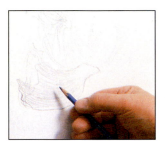

1 When producing a drawing integrating graphite and colored pencil textures, begin working with the graphite to set the linear framework and dark tones.

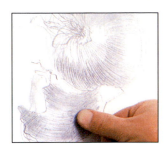

2 Soft graphite spreads easily when rubbed with the fingers. In this example, the shadow areas are softened by rubbing.

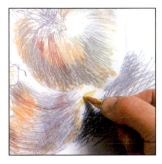

3 The range of colors on the onion are introduced with light shading and hatching in yellow, yellow ocher, and burnt sienna.

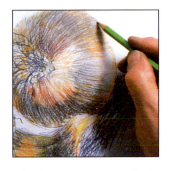

4 As the drawing progresses, further colors are applied to obtain the subtler hues and shadow colors. The textures of the graphite and colored pencils are allowed to mix freely.

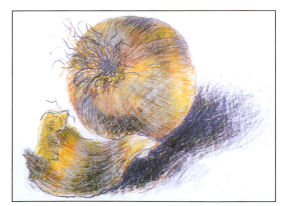

5 In the finished drawing, the color is built up gradually to develop solid form. The graphite pencil is used again to sharpen some of the line detail in the drawing, enhancing the veined effect of the onion skin.

INK AND PENCIL

Black ink line has a fluidity and clarity that marries well with the soft textures of graphite and the bright colors of the colored pencil.

Ink produces a clean, graphic framework that supports the tone and color work. You can combine the different line qualities of the media and integrate them using tonal techniques such as hatching, shading, and stippling.

Like pencils, pens and inks provide a wide range of visual properties, from the fine, uniform line of technical pens and rapid, flowing action of felt-tip pens to the sensitive variability of dip pens with pointed or squared nibs. Black drawing inks are dense and velvety, while writing inks often have subtle blue or sepia tints. You can also combine colored pencils with the extensive palette provided by colored drawing inks in similar ways.

1 A simple outline drawing of the view is constructed using black waterproof ink and a dip pen with two different types of nibs. The intention is to create a strong graphic framework for the image, and then to add color and texture with the pencils.

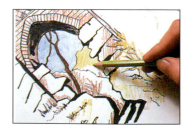

2 To begin with, a basic impression of local colors is blocked in with light shading, identifying brickwork, stone, trees, and grass.

3 Each area is given more textural interest, overlaying hatching, shading in linear marks, and gradually increasing the color range.

4 The waxy texture of the pencils has softened the blacks where color has been freely worked into the drawing. More drawing is done with pen and ink to sharpen and strengthen the linear textures.

5 With the increasing density of both media, the drawing has a more cohesive effect, with a livelier interplay between the black line and pencil color. None of the detail is "realistic" (right), but the drawing has a descriptive character.

LINE AND WASH WITH PENCIL

Traditionally a technique associated with pen and ink drawing, line and wash is a method of adding tone and color to an image with a strong linear framework.

The lines create the structure of the composition; modeling and color detail are then introduced with washes of diluted ink or watercolor.

Lines made with ink or graphite pencil are typically black or very dark in color, standing out quite strongly against the fluid, paler areas of wash. If you use colored pencils for the line element, they contribute a new dimension in which you can use color to enhance the impressions of space and form created in the initial drawing, or to emphasize a mood. You can flood the washes into and over the colored pencil lines, and when they have dried you can use the pencils again to rework basic structures and develop the detail. Remember that working over color washes will somewhat modify the intensity of the pencil hues.

A very direct way of exploiting this technique is to use water-soluble pencils, used dry for drawing, then brushed over with clean water. In this way the texture of the line and wash elements are more closely integrated.

USING WATER-SOLUBLE PENCILS

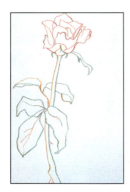

1 Make an outline drawing of your subject with firm lines and strong colors. The line needs to be quite heavy, as you will be using the pencil pigment to create the wash.

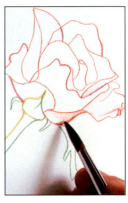

2 Moisten a fine sable or synthetic, soft-haired brush with clean water. Brush just inside the penciled line, picking up and spreading the color into the shape.

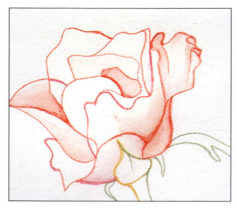

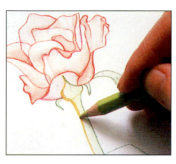

3 Continue in the same way, gradually shading and blending the colors to produce a range of hue and tone. If you do not have enough intensity in one area, go over the pencil line again and dissolve more of its color with the brush tip.

4 At each stage of the drawing, you can choose whether to strengthen the line work or deepen the washed color. Be careful when working in water-soluble pencil over a wash, because the moisture softens the pencil tip and spreads the line.

LANDSCAPE BY DAVID HOLMES
This free abstract interpretation of landscape in line and wash shows the different, very striking effect of strong color areas overlaid with calligraphic, grainy pencil strokes. The watercolor wash appears more solid and opaque because of the intensity of the hues.

5 This approach to line and wash drawing produces a delicate color effect, as the washed color is relatively lightweight. To produce a denser, more graphic image, use paint washes.

MARKERS AND PENCIL

This combination of media has been widely used in design and illustration for preparing presentation visuals and images for print.

A drawback of using markers for artwork intended to have long-term display potential is that some markers are not color-fast, and colors may fade or even disappear altogether when exposed to normal lighting conditions over a period of time.

However, markers and colored pencils make an attractive and versatile partnership. Broad markers are often used to block in areas of solid and blended color, with colored pencil employed to impose a linear structure and fine detail work. But as both can be used to create either line or mass, you can investigate different ways of putting them together to suit your drawing style.

There is a choice of marker types, from very fine fiber-tips to thick, rounded or wedge-shaped felt-tips, and colors range from subtly varied neutrals to brilliant, strong hues. The least expensive brands tend to contain a limited range of bright colors, while the more costly ones used by professional designers provide an extensive palette of graded hues and tones.

1 An advantage of using broad markers is that it is easy to block in an impression of three-dimensional form very quickly. In this case, nonrealistic colors are chosen, but the particular hues are selected to provide light, medium, and dark tones for modeling the camera body.

2 The marker drawing is reworked to increase the sense of solidity and suggest the shapes and textures of individual parts of the camera.

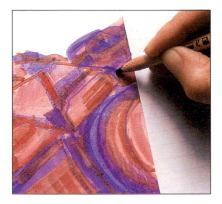

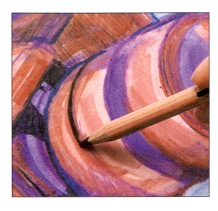

3 The colored pencil work begins with contour drawing in dark indigo blue, to correct the outline shapes and give a firmer structure to the drawing.

4 A black pencil is used to shade solid tonal blocks over the marker color and to indicate textures and more precise contours.

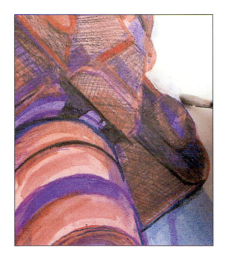

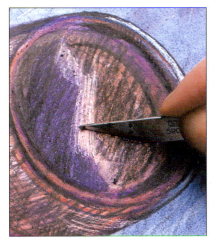

5 White gouache is painted on to block out the shape of the camera against the background, covering stray touches of marker and pencil color that were incorrectly applied.

6 Where the color has been built up densely on the camera lens, a scalpel blade is used to scrape back the surface to bring back white highlights on the glass and outer rim.

7 The finished image shows how the pencil work has been built up over the marker color to define detail and enhance the weight and texture of the object.

FINE MARKERS

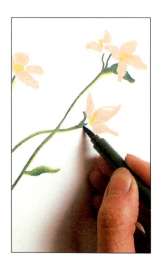

Fiber-tip pens and fine markers can also be used with colored pencils, naturally forming a more delicate image than broad markers, which is more suitable for small-scale subjects.

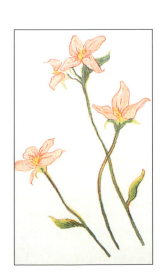

PASTEL AND PENCIL

Like pencils, pastels can be manipulated to exploit their linear qualities or to produce color masses and complex surface textures, so a combination of the two media is generally sympathetic.

Another thing that pastel and pencil have in common is that there are different types of both, caused by variations in the composition of the binder that holds the pigment, and qualities also vary between different brands.

There is no specific recipe for mixed-media work; individual artists develop personalized methods that produce effects suited to their style and subject matter.

The different types of pastels are soft pastels, hard pastels, oil pastels, water-soluble pastels and pastel pencils. All combine readily with colored pencils and contribute varying qualities of color and texture. The greasy texture of oil pastel is more resistant to colored pencil than the dry, powdery finish of soft and hard pastels, but you will find that effects differ according to the properties of the particular brands you are using, the pressure you apply, and the density of the color build-up.

1 The drawing is loosely blocked in with soft pastels and pastel pencils to create grainy blocks of color establishing the general shapes of the plant's leaves and stem.

2 Waxy pencil is used to define the contours of the leaves and develop a sharper, more distinct image.

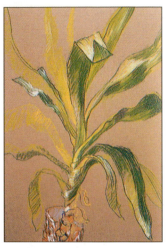

3 Details of the textural qualities of the leaves and stems are enhanced with line work and shading, laid in with waxy and chalky pencils.

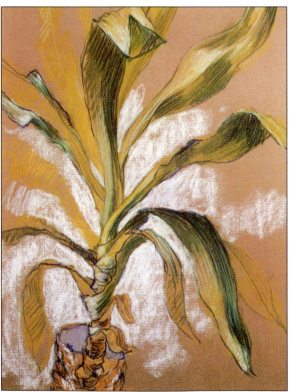

4 With the structure of the plant more clearly defined by the pencil work, soft pastel is again used to introduce highlight areas and block in a pale background. The contrast of hard line and grainy color (see detail above) gives richness and depth to the rendering.

WATERCOLOR AND PENCIL

Watercolor is a translucent paint medium that combines well with the clear hues of colored pencils.

Watercolor and pencil can be loosely integrated in free, impressionistic images or used in a more formal way to create finely structured color drawings.

The clean, crisp line qualities that you can achieve with colored pencils form a striking visual contrast with fluid brush strokes and washes laid in with watercolor. An interesting effect comes from applying water-soluble pencils while the paint layers are still damp; the moisture softens the pencil tip, encouraging broad, brilliantly colored marks. Be careful when working into watercolor with non-soluble pencil types, however, as the pencil point is likely to tear the wet paper surface. If you wish to apply detailed line work, wait for the watercolor washes to dry completely.

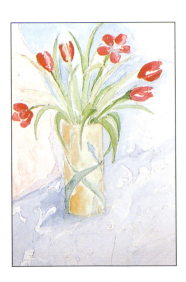

1 You can begin by blocking in with watercolor, or you can start with a colored pencil outline and paint into it. Here a faint outline has been drawn to establish the composition and the basic colors are freely washed in.

2 Successive washes are overlaid to build up the paint colors, with the linear forms of the stems and leaves strengthened with light shading in waxy colored pencils.

3 Some shading is put in behind the flowers to develop the relationship of shapes against the background. At each stage the technique is quite free, leaving the surface open and workable.

4 The process continues, working back and forth between different shapes to enhance the definition. Avoid drawing over painted areas that are still wet, as the pencil tip could either slide, or tear the paper surface.

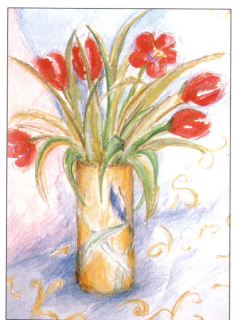

5 Where the initial washes have suggested shadow areas, the pencil shading is built up more strongly to heighten the intensity of color and tone.

6 The combination of pencil and watercolor allows you to develop a free interpretation. The paint provides the overall impression and the pencil marks emphasize structure and linear detail.

MAKING CHANGES

All of us, at some time or another, make mistakes, but before crumpling up your work and giving up in despair, you might try some of the following handy tips.

For each medium there are different ways of making corrections. However, often you will not need to make a correction and can adjust your work to include your mistake, or even turn it to your advantage. You can help prevent mistakes by using a clean sheet of scrap paper under your hand to prevent smudging and moisture or grease from spoiling the surface of the paper. Always have a roll of paper towels at hand. Use paper towels as tissue tends to disintegrate too easily. Paper towels can help in a multitude of situations, from mopping up water spills, to cleaning up edges or removing a too-wet wash.

Learning how to correct work so that it does not show will save the artist time and money. The method chosen will depend on the materials used and, most important, the intended use of the drawing or illustration. A black and white drawing, for example, can be corrected with white gouache or correction fluid if it is to be reproduced photographically, but for a presentation, some other means would have to be sought.

BASIC EQUIPMENT
A most useful piece of equipment for erasable media is the kneaded (putty)

eraser, which is far more versatile than an ordinary eraser. It can be molded into a fine point for small detailed areas and it does not leave your work and the studio floor covered in "eraser crumbs." Also invaluable are white gouache or white correction fluid, an old but clean brush, a scalpel handle, and a selection of blades.

GETTING STARTED
Work using graphite pencil, charcoal, and water-soluble pencil, if the paper is strong enough, can all be erased with a kneaded (putty) eraser, or, if more pressure is needed, a traditional eraser. Scalpel blades can be used to scratch away mistakes made in waterproof inks, wax crayons, and oil pastels. The blade particularly suitable for this is a size 10, as it has a rounded end to prevent you from cutting the paper. Small areas may also be corrected with white gouache or correcting fluid. It is possible to build up the layers of gouache until the mistake is completely hidden; the only drawback is that it cannot be worked over. For opaque media, making corrections is easy, as the mistakes can be worked over once the area is dry.

107

CORRECTIONS

Drawings do not have to have all the "errors" removed. There are many line drawings, by artists such as Ingres (1780–1867), Degas (1834–1917), or Matisse (1869–1954), where several attempts at, for example, positioning the leg of a figure have been left in the final drawing.

Visible alterations are known as pentimenti and, curiously, they enhance the end result, rather than detracting from it. There are times, nevertheless, when necessary corrections cannot be made without removing or obliterating what is on the paper. The most usual way is by using an eraser (there are several kinds with different degrees of hardness).

Sometimes a hard eraser is sufficient to remove ink, but more usually a sharp knife or razor blade is necesssary to scratch off the ink. Opaque white paint (gouache or acrylic) will obliterate most forms of drawing; and when all else fails the relevant piece of paper can be cut from the drawing and an identical piece inserted in its place. The new piece is attached by sticking gumstrip on the back of the drawing

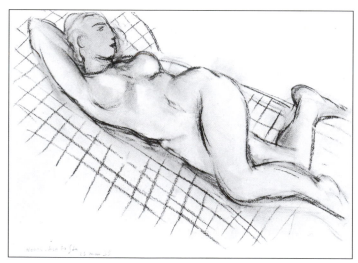

STUDY FOR PINK NUDE BY HENRI MATISSE
This charcoal sketch demonstrates Matisse's marvelous sense of rhythmic line and form. Positional lines have been left in this sketch around the body and legs; this also emphasizes movement in the model.

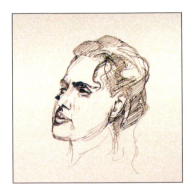

When the artist was making a bold pen and ink drawing a blot of ink disfigured one side of the face. He decided to correct this and the position of the eye above it. Using an opaque white paint called process white he paints out the area to be corrected. Once the paint has dried thoroughly the lines are redrawn and the portrait completed.

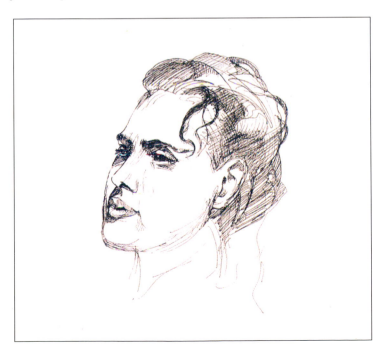

PATCH CORRECTION

It can be very frustrating when you have put a lot of work into a colored pencil drawing to find that one area simply does not work, and attempts to correct it make the effect worse rather than better. Repeated overworking may make the surface slippery and resistant, while heavy erasure can ruin the paper.

If one part of a drawing has gone completely wrong, you do not have to abandon the whole thing. You can make a patch correction that sits flush with the rest of the drawing. You create the patch by cutting through a piece of clean paper at the same time as you cut out the error, so it is exactly the right shape. You then insert it in the drawing, secure it with adhesive tape on the wrong side, and rework that section of the image.

Although this type of correction can be almost invisible, the fine seam around the new patch may snag the pencil tip, picking up a heavier color application that could draw attention to the outline. The technique works best, therefore, in a drawing that is composed of distinctive shapes. However, by working very carefully toward the edges of the patch you should be able to integrate the redrawn section quite effectively.

1 In this drawing there is a round shape in the foreground that relates to an element of the composition subsequently deleted. Because the pencil lines are hard, the shape cannot be covered by overlaying color.

2 The area containing the round shape is cut out following as far as possible, hard edges already established in the drawing. A clean sheet of paper has been laid underneath, and the cut is made through both layers.

3 Both pieces are lifted out after cutting. Working through both layers ensures that the clean patch is cut to exactly the same shape as the piece being removed.

4 The clean patch is inserted in the "hole" in the drawing to check the fit.

5 Once firmly in place, the drawing is turned over and the patch is secured with masking tape along all the cut edges. From the front of the drawing, the patch fits neatly, with no overlap on the edges that would form an awkward ridge to catch the pencil tip.

6 As the colored pencil drawing is gradually reworked, with pencil strokes crossing the patched section in different directions, the edges of the patch become less noticeable and the new section can be fully integrated.

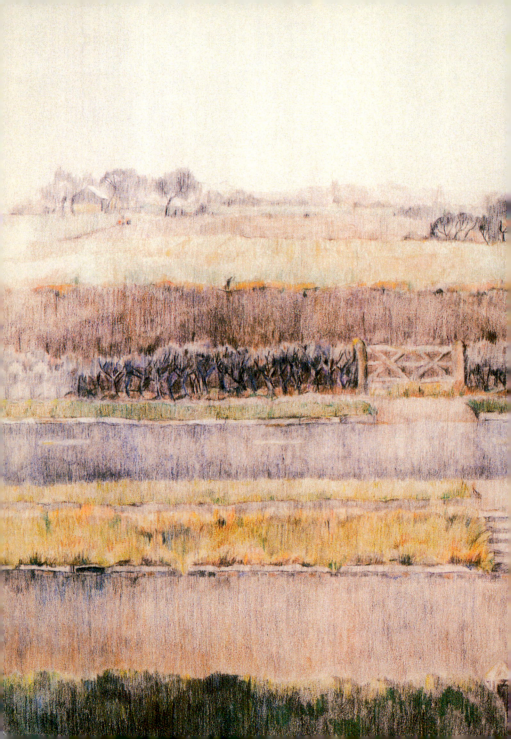

COMPOSITION

The theories of composition and perspective and the study of human anatomy have been a lifetime's work for some artists, while others have been unaware of their existence yet have produced excellent drawings. It is probably true to say, however, that many of the great works of art that appear to ignore the theories are the result of a deliberate turning away from rather than ignorance of these complex topics.

Any aspiring artist is well advised to try to come to terms with as much theory as possible. By looking at reproductions in books and visiting galleries you will be able to compare the ways in which various artists have dealt with problems of composition and perspective. Perhaps the most useful method, however, of learning about these subjects is through your own work. By setting yourself exercises and trying to complete them in the light of what you have read and observed you will gradually acquire greater understanding and be able to put this to practical use.

COMPOSITION

The word "composition" has a slightly alarming ring to it — it sounds as though it might be an intellectual exercise quite beyond the capabilities of the ordinary person. This really is not so: composing a painting is mainly a question of selecting, arranging, and rearranging, just as you might do when deciding on the decor for a room or when taking a photograph.

A large, complex drawing with numerous people and objects in it does, of course, need some thought, otherwise there may be too much activity in one part of the picture and not enough in another. But even here, it is less a matter of following a prescribed set of rules than of working out the balance of the various shapes, as in the case of planning a room — no one would put all the furniture crowded together on one side and leave the rest empty. A "good composition" is one in which there is no jarring note, the colors and shapes are well balanced, and the picture as a whole seems to sit easily within its frame or outer borders. Even a simple head-and-shoulders portrait is composed, and a vital part of composition is selection — what you put in and what you leave out. In the case of a portrait you will need to establish whether the person should be seated, and if so on what, whether you want to include the chair, whether you want the hands to form part of the composition, and whether you want to use something in the background, for example part

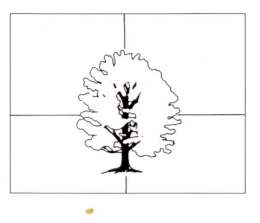

As the tree is moved to different positions on the picture plane, the composition of the picture is radically changed. Although it is an identical drawing in each case, the composition of each example is quite different, thus illustrating the fact that although the subject matter can be important in making an interesting drawing, it is not necessarily the most important. It is more important that the position of the subject matter within the four sides of the picture plane will make an interesting composition.

of a window frame, to balance the figure.

If you are drawing a landscape you may think composition is not involved, that you are just painting what you see, but you will have

chosen a particular view, just as you would when taking a photograph, and in choosing it you will have gone at least some way toward composing it. You may then find that you want to exaggerate or rearrange some feature in the foreground, such as a rock or a tree, to provide extra interest, or alter the bend of a path to lead the eye into the picture. There are some basic errors that should be avoided if possible. In general it is not a good idea to divide a landscape horizontally into two

Painters of the Renaissance usually planned the composition of a painting on a geometric grid structure. This example, by Piero della Francesca, is based on a triangle, a common compositional device that is still much used, as are circles and rectangles. The drawing on the right below shows how other triangles can be discerned within the main one formed by the figures.

A temporary viewfinder helps select a viewpoint on location. Holding your viewfinder close shows a wide vista; moving it farther away selects a smaller area.

equal halves – the land and the sky – as the result will usually be monotonous. A line, such as a path or fence, should not lead directly out of the picture unless balanced by another line that leads the eye back into it. A still life or portrait should not be divided in half vertically, while a flower painting is unlikely to be pleasing to the eye too far to one side, or very small in the middle, with a large expanse of featureless background.

In the case of interior, portraits, still lifes, and flowers, backgrounds can be used as a device to balance the main elements of the composition. Use part of a piece of furniture behind a seated figure, for example, or a subtly patterned wallpaper that echoes or contrasts with the main shapes and colors in the figure. In landscape painting the sky is a vital part of the composition, and should always be given as much care and thought as the rest of the painting.

Even if you are working quickly, it is often helpful to make some drawings, known as thumbnail sketches (though they need not be small) before you start on the painting. These may consist of just a few roughly drawn lines to establish how the main shapes can be placed, or they may help you to work out the tonal pattern of the composition.

GOLDEN SECTION

The division of space known as the Golden Section is perhaps the best known system of proportion in pictorial composition.

The simplest method of finding the Golden Section in any given rectangle is to take a sheet of paper of the size one is working on and fold it in half three times in succession (do this for both the length and width of the paper). The folds will divide the paper into eight equal parts, from which a 3:5 ratio can be determined. (Alternative ratios might be 2:3, 5:8, or 8:13). In the work of artists such as Piero della Francesca, the vertical division of the Golden Section is used to determine the placement of the central figure of Christ. Similarly, in the work of other painters, it is used to place the most important element in the composition. As we develop our powers of observation, however, we sometimes unconsciously place the most significant vertical element in our drawing on that same division in the painting. In landscape the horizon presents a natural division of the total area of the painting. In lowland areas, where the sky is dominant, the horizon will be quite low, as in the work of Rembrandt and other Dutch painters. Where there are hills and mountains, the horizon might be placed high in the composition to give emphasis to rising forms.

There are certain compositional conventions that appear time and time again in "picturesque" paintings: rivers and paths that lead the eye

The requirements of the Golden Section are fulfilled by this sketch from the notebooks of J. M. W. Turner. It was on this theory of the Golden section that the Greeks based their definition of perfect proportion. In this sketch the horizontal line of the jetty and the

verticals at its far end conform to the ideal positions described on the opposite page.

from foreground to significant objects in the distance; trees with masses of foliage on one side with glimpses of the distant horizon bathed in sunlight; and so on. When one is producing a landscape painting from direct observation one has the advantage of being able to leave out anything one might consider excessive to the composition as a whole. And it is this fact that distinguishes the work of the beginner from the more experienced painter. When we first start to draw from direct observation, we put everything in, but with experience we learn to be more selective – to imply, rather than overstate.

To find the section, divide the line AB in half at C; draw a radius from the top right hand corner of the cube to create D. In the drawing bottom left, lines have been drawn to create a rectangle; point BG forming the vertical section. To find the horizontal section (bottom right) draw a line from the top of the vertical G to the bottom right hand corner and a radius from the top right hand corner downward; the line and arc intersect at the level of the horizontal section.

COPPING HALL

BY JOHN TOWNEND

The sweeping space of the landscape is achieved by locating the focal point of the building on the horizon line and emphasizing the curve in the foreground. Layers of loose shading create a rich impression of autumnal colors.

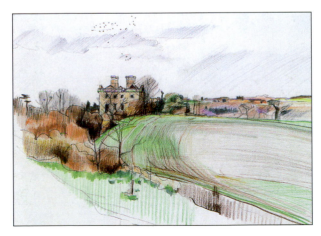

DRAWING IN TWO DIMENSIONS

Drawing creates the illusion of three-dimensional space on a two-dimensional surface. When drawing from observation, you are opening an imaginary window for a viewer to look through at your representation of reality.

The visual journey, around and through this spatial illusion, needs to be organized. By making sketches or thumbnail drawings beforehand, you can check the two-dimensional layout or the distribution of shapes across the flat surface.

Two-dimensional design is concerned with the flat layout of a drawing and the dimension of forms and spaces, lights and darks, plain areas and textures, across the whole span. Draw into all the areas as you define them, rather than treating them as linear silhouettes. Work broadly at first, then in more detail as you verify your original statement – this approach helps you to draw accurately. Line drawing is fast, but because it involves drawing white spaces that are hard to evaluate, it makes it difficult to establish proportions and dimensions.

To convey solidity, you need to trigger the perception of three-dimensional space. There are many techniques for achieving this; the most useful give visual clues that the viewer associates with an experience of real space, and are usually simple. The first technique is vertical perspective, which creates apparent recession by arranging items vertically in the picture while diminishing their scale. This relies on the understanding that distance makes elements and the spaces between them appear smaller. This particular illusion is more convincing if you overlap items, because intervening objects often obscure distance in reality.

Single-point perspective is a mathematical system that represents visual space by identifying a vanishing point, the spot on a nominal horizon where the extensions of all the horizontals in a drawing would vanish. Draw everything horizontal to the picture plane so that it appears to slope up if it is below your eye level, and down if it is above. This creates diagonal directions that are useful for bridging the lattice of horizontal and upright lines on view. Semicircular alignments also have a role; by selecting them for emphasis, you can use them to move the eye from one stopping point to another, across and through the span of a drawing. Vertical forms provide punctuation points among the horizontals, and also appear to diminish with distance. Draw them progressively shorter, and reduce the spaces between them.

PERSPECTIVE

Drawing need not be the result of clinical observation at the expense of expression, and it is worth considering how some artists have come to terms with methods of representing the visual world with some accuracy.

The predominance of realism in Western art has hindered an appreciation of drawing as an art in itself; in Eastern cultures there has been less emphasis on the imitative quality of drawing and more appreciation of line and shape. However, developments that have been made with the aim of naturalism were inspired by a growing awareness of perspective. The use of perspective as an aid to figurative drawing reached its peak during the Italian Renaissance. By establishing a fixed viewpoint in relation to a given subject it was realized that an image could be drawn that suggests how an object could be drawn which suggests how an object is perceived in space. This contrasts with the image behaving as a symbol that describes an object's obvious two-dimensional qualities without implying its relative position to the spectator.

If an artist wants to draw a pair of scissors, the outline or silhouette is sufficient to strike a chord in the observer and the image will be instantly recognizable. If, however, the same object is seen from a viewpoint that is not symbolic, the problem of conveying its shape naturalistically is

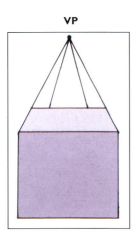

VP

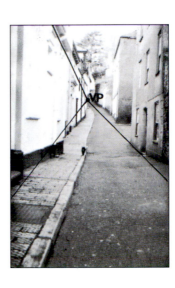

One-point perspective
Only two faces of an object are visible and there is one vanishing point. A good example of a single vanishing point is provided by the photograph, right. The parallel lines of the sides of the road appear to converge at a point on the horizon.

more complex. The same situation occurs when an artist is confronted with a model; the artist must acknowledge the difference between what he knows to be real and what he actually sees.

Before beginning a drawing it may be useful to indicate the eye level and establish an imaginary horizontal plane between the artist's eye and infinity which will dictate the height of the horizon. This level will rise or fall according to the position of the artist, and even though the drawing may proceed in an intuitive manner it is important that this level be related to the position of the model. In theory it is assumed that all parallel horizontal lines converge at a point known as the "vanishing point"; in practice this

may be evident by standing on a street and noticing how the buildings appear to diminish in size the farther away they are. The parallel lines of the rooftops and pavements on either side would converge to a single point if the street were long enough. The vanishing point depends for its position on the viewer's eye level, which is a vital consideration in the composition of a picture.

Although it might be assumed that drawing a single figure would not involve perspective, it becomes apparent that the relative position of artist and subject will affect the drawing. If the artist is positioned at the same eye level as the subject and also very close, the subject's head will be seen at eye level but the whole

VP **VP**

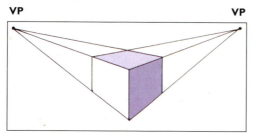

Two-point perspective
Here, three planes of the cube are visible, the top and two of the sides, so there are two sets of receding parallel lines and two vanishing points. The photograph of a street corner (bottom) is a good example of two-point perspective, the two sets of lines from the top of the building and the pavement converging at two vanishing points.

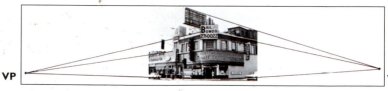

VP **VP**

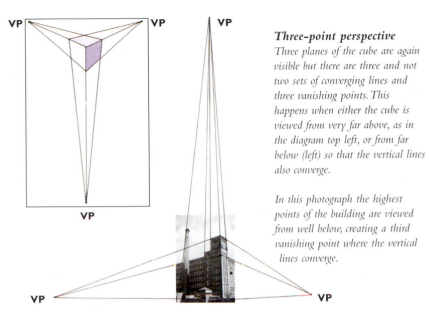

Three-point perspective

Three planes of the cube are again visible but there are three and not two sets of converging lines and three vanishing points. This happens when either the cube is viewed from very far above, as in the diagram top left, or from far below (left) so that the vertical lines also converge.

In this photograph the highest points of the building are viewed from well below, creating a third vanishing point where the vertical lines converge.

body will be seen from above. If the model is seated on a chair and viewed from a close vantage point the thighs will be seen from above. If the artist moves further away, the thighs will appear to be foreshortened and the discrepancy of viewpoint will be less evident.

The complexity of many realist paintings provides a paradoxical result in the realization of this phenomenon. In the work of Jacques-Louis David and Ingres the clarity and detail evident in some portraits suggests that the subject was seen from a close vantage point, and yet the particular application of perspective contradicts this by implying that the whole figure was observed from some distance. More recently Euan Uglow (b.1932) has deliberately emphasized this visual distortion but many artists have compensated for it in an attempt to convey a more acceptable representation of reality.

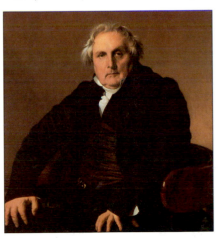

MONSIEUR BERTIN
BY JEAN AUGUSTE DOMINIQUE INGRES

GRASPING PERSPECTIVE

Perspective governs everything we see; even in a simple landscape of fields and hills the way in which a wall twists and narrows, or the furrows of a plowed field change direction explain the lay of the land and help to create a feeling of form and recession.

The furrows in a plowed field run across our vision, the spaces between them becoming progressively smaller as the field recedes.

Now our viewpoint is altered, so that the furrows run away, converging at a vanishing point on the horizon.

In this mid-view, between that of the two previous examples, the lines still converge on the horizon, but the vanishing point is some way out of the picture.

This wide-angle view shows that we do not really perceive the line of the furrows as straight.

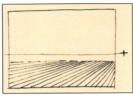

The vanishing point must always be on the horizon - that is, at our own eye level — if the ground is flat, but it will be within the picture area only if it is viewed straight on.

If there is a dip in the ground the furrows will follow it, thus taking their vanishing points from the angle of indentation, which theoretically alters the horizon line. This is an important point to remember in landscape drawing, as the land is seldom completely flat.

When viewed from a distance, the two sides of a church tower appear to be vertical.

However, when seen more closely, the side walls appear to converge. The lower the viewpoint, the more sharply they do so.

When seen from above, the sides appear to converge at the bottom.

When the tower is seen from an angle, each side will have its own vanishing point. When drawing or painting buildings it is all too easy to forget this.

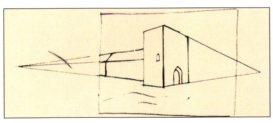

Leonardo da Vinci's preparatory study for the background to The Adoration of Magi. Note the vanishing point to the right of center.

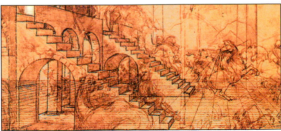

AERIAL OR ATMOSPHERIC PERSPECTIVE

Aerial or atmospheric perspective increases the illusion of depth by concentrating on the atmospheric conditions that intervene between the observer and the subject. The basic idea is that objects that are close up will retain their full color and tonal values and be clearly identified while distant objects will have their tones modified by the atmosphere.

In the time of Pieter Breughel (c.1525/30–1569), and during the 17th and 18th centuries, the suggestion of receding tracts of land or sea within a picture was achieved by means of a well-established formula. By the use of strongly contrasted tones in the foreground (usually browns), through bright green in middle distance, and progressively paling blues in the far distance, the eye was encouraged to travel back and long distances could in this way be suggested. J. M. W. Turner (1775–1851) followed this method in a great many of his paintings and by this time the conventions for conveying distance were less rigid.

Although easier to suggest in paint with the benefit of a full color range, aerial perspective is nonetheless important to drawing too. Vincent van Gogh (1853–1890) made pen and ink drawings in which he employed a great range of marks – dots, dashes, strokes, and lines – strong in pressure in the foreground and more delicate in the background. This variety expresses the feeling of traveling back into the distance. The wood engravings of Thomas Bewick (1753–1828) use a cunning device to suggest this "blueing" of tones as they recede.

With only black on white available, engravings have a great deal in common with monochrome drawing and the problems encountered in making them. Bewick engraved the major elements of his design – usually a bird or an animal – with the full, rich tonal range of his medium. The related landscape context for his creature would be engraved with finer gravers and the surface of the wood would be very slightly lowered so that when spread with black ink and passed through a press, less pressure would be applied to these parts, resulting in a lighter tone.

Ingres (1780–1867) made pencil portraits in which textures and details are rendered with great fidelity in the subject figure or figures but the backgrounds are limited to relatively simple linear suggestions of buildings or interiors. This system works well, as do similar but more tonally complete drawings such as those made by Edgar Degas.

THE CORN HARVEST BY PIETER BRUEGEL

FIGURE PERSPECTIVE

An understanding of perspective is essential if certain pitfalls of figure drawing are to be avoided. Work at a distance from your model that enables you to encompass the whole of the figure at one glance, so avoiding the optical distortions that arise if you are too close to head or feet. While you are still a beginner it is easier to make a properly proportioned figure if the feet, head, hips, breasts, hands, and other parts of the body are all at the same distance from your viewpoint.

Within the figure, symmetry happily lends itself to a simple perspective structure, parallel features such as eyes, ears, and nipples making it easy to relate one to the other spatially. By the principles of foreshortening, objects closer to the eye appear greater in size than those at a distance. The creative use of this distortion can be incorporated into a drawing, although in the case of extreme foreshortening, when the figure is seen from very close either to the head or the feet, there are many problems of perspective. We are familiar with the normal proportions of the adult and it can be difficult, under different circum-stances, to make convincing the relationships of the various parts. It is necessary to measure carefully in the traditional way, by holding the pencil at arm's length and squinting. The parts of the body nearest to the artist will appear much bigger than those farthest away.

LIGHT AND TONE

All types of drawing require an understanding of relative tone and the distinction between tone and shadow.
Tone is dependant upon light; it is in effect the other side of the light area of a solid form.

The reason for considering drawing in linear terms is not to exclude other approaches but to establish an idea about the nature of perception without attaching too much importance to the effects of light and shade. The addition of tone should not be considered as an embellishment to line drawing, but its use is often the result of the desire to compensate for a lack of three-dimensional volume that probably arises from a misunderstanding of the nature of linear drawing.

A specific problem for the artist in the twenty-first century is the acceptance of visual material in photographs. The photographic image is by its very nature reliant on light and shade, however, the tonal quality can provide a false yardstick for the artist and the pitfalls of imitating the apparent naturalism of photographs should be avoided. A photograph of someone's face in strong sunlight can result in an image that is predominantly dark or light and lacking in half-tones. If this effect is copied in a drawing, with dark patches acting as approximations of shadow, the volume of the form, especially in the shaded areas, will be

flattened. If a photographic use of tone in a drawing is falsely equated with realism, an understanding of the language of drawing will suffer; "dark patches" usually amount to a disappointing over-simplification of tonal values. Tone in drawing can in fact be variously used for many purposes.

In figure drawing the use of tone is particularly important, for when elaboration is required – for example into a portrait likeness or to describe fur collars or other textures – it is likely that purely linear solutions will prove inadequate

Examine a sphere with one source of light, in other words a stream of light coming from one direction only, and observe through half shut eyes. This method of analyzing tonal values is very useful, for by narrowing the eyes in this fashion the relationship between darks and lights is heightened; with half tones, mid-grays to light grays for example, it proves essential.

The sphere sits on a flat surface, lit from one side. Apart from the shadow cast from it onto the supporting surface, a full range of tonal contrasts will be apparent

A combination of drawing and collage is used here to make a richly textured tonal image. Tracing paper is the basic material and the artist applies pencil (below) to create various tones. The paper is then torn or cut into pieces which are glued to a full sheet of drawing paper (below left) to build up the image. The effect is subtle and rewarding and is applied here to a simple but extremely well-judged composition (above left).

within itself, from the area closest to the light source to the darker parts turned farthest away. This is the basis of understanding relative tone and its use in describing solid forms with pencil or other drawing tools.

Shadows are the projected shapes of the lighted object onto other surfaces – useful when understood fully but dangerous if misused or allowed to take over control. It is essential always to be aware of the differences between tone and shadow.

LIGHT AND SHADE

The brilliant colors of flowers may be what make you want to paint them, but to give credibility to your work, you must also consider tonal values.

Tone means the lightness or darkness of a color, and you will see many variations even in one flower or plant. Parts may be catching the light, so that they are light in tone, and others in shadow, and hence dark. Even a white or pale-colored flower may be surprisingly dark in places, for example beneath the petals, and sometimes there may be light shining through a leaf or petal to create a tone so light that it seems to belie the overall color. You will learn how to pick up on this with good observation. When you first sit down to study the subject look for the lightest (almost white) areas and then the darkest shadows (almost black). Everything else will come somewhere in between on the "gray" scale. Make

tonal sketches marking important areas so that you get the feel of the distribution of tones.

The fall of light will also create shadows, thrown by an object onto an adjacent surface, or by one flower or leaf onto another. These not only give form to the main subject but "recognize" the surrounding objects, thus linking all the elements in the picture.

Light and shade could be said to be the most important part of a painting, because it is these that give form and solidity to the subject. It is not always easy to judge tones independently of color, but try, as you introduce color, to keep an image of what the subject would look like in black and white. It is helpful to half-close your eyes – try this looking at a painting on the wall. The slightly out-of-focus effect accentuates the pattern of light and dark and reduces the impact of the colors.

GRAY SCALE
Pencil sketches rely solely on varying shades of grays to give shape and form. This gray scale is useful when considering tones in a color drawing.

AS LIGHT MOVES THE TONAL QUALITIES SHIFT

Bright side lighting gives contrasts and deep tonal shading to the upright lines.

Soft light from the side gives more overall tonal quality. Each flower has equal emphasis.

Lit from above, the vase loses emphasis, leaving only subtle tones as guides to shape.

Light from behind reverses the rules as it shines through the translucent petals.

A vase of roses in full color is brightly lit from the side; note the tones, then imagine it in black and white. Compare these shapes with the example (left). The tips of the red roses are white, and the cream roses have shadows that are nearly black.

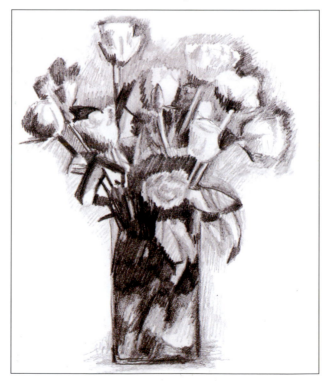

Color may be your first consideration, but tones give dimension and texture. Make a monochrome drawing to fix in your mind the light source and consequential shadows.

LIGHT AND ATMOSPHERE

If you are working in pencil only, qualities of light and atmospheric impressions can be difficult to handle. Whereas with paint or pastel you can rely on overworking with pale tints to retrieve the lights and modify blends and color mixes, with graphite and colored pencils your means of adjusting the high-key tones are restricted if you have laid in tones or colors too heavily or broadly. You need to have an organized sense of the composition from the start, especially if you rely on using the white of the paper to make the highlights.

Degrees of tonal contrast have to be exaggerated to achieve a vibrant impression of light effects. Colored pencil drawing allows you plenty of time to build up contrasts; if you find the drawing looks flat, don't be afraid to attempt radical measures, introducing a darker color or more vivid hue.

You may wish to work very quickly and spontaneously to develop the mood of a landscape deriving from the quality of light or particular weather conditions. Mixed media approaches are frequently successful for landscape work.

FOREST LIGHT
BY MIKE PEASE
The effect of strong light is created with tonal contrast. Here, there is a misty, fragile quality to the rendering – due to the muted background colors and smaller, more intricate shapes.

133

COLOR STUDIES

Rather than trying to match the individual colors that you see in nature, you need to develop the skills of analyzing color relationships and finding satisfactory equivalents by manipulating the qualities of hue, tone, and intensity in your pencil colors.

When choosing colors, important factors to consider include the extent of one color against another, whether mixed color effects are best achieved by interweaving or juxtaposing the pencil marks, and the selection of hues and tones that interact to create the right nuances.

Qualities of light and shade should be achieved with vibrant mixes to keep the picture surface alive; using the neutrals – black and white – to strengthen tonal contrasts can deaden the image. Dark shadows can be shot through with red-brown, indigo, or purple; highlight areas can be intensified with touches of bright pink or yellow.

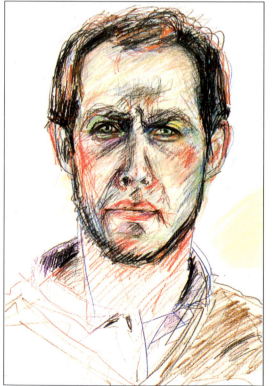

SELF-PORTRAIT
BY JOHN TOWNEND
The strong contrast of black and red, further enlivened by the complementary contrast of green shadow areas, presents a powerful, almost aggressive study of the face. The mood of the portrait is emphasized by the busy activity of the pencil marks, weaving over and around each other to describe form and texture.

CALA HONDA, SPANISH LANDSCAPE BY **STEVE RUSSELL**
Soft-leaded waxy pencils are combined with chalky pastel pencils to provide the bright color scheme of this sunlit view. Using broad patches of bold color gives an exotic impression, enlivened by formal pattern elements in the foreground.

An unusual background texture was introduced into this drawing by smoking the sheet of paper. The eagle's head was then sketched in with pencil. Next masking fluid and watercolor washes were used in combination to develop the texture of the feathers. Finally, the extremes of the tonal range were built up, with opaque white gouache forming the highlights – as seen on the tips of the feathers – and ink strengthening the darkest lines and tones.

SHAPE AND CONTOUR

A drawn mark conveys a degree of tonality but is not enough to show contours well. Where circular lines are used to indicate modeling around the eye, jaw, or cheek, for example, the lines lead the viewer's eye in a general direction.

UNDERSTANDING CONTOUR

Shape and contour are subtle complexities that must be represented: though they are broadly round or cylindrical, heads, bodies, and limbs show considerable variations in volume and changes in curvature throughout their length. The contours in parts, such as hands, feet, and facial features, alter with a tiny span, and directional lines cannot describe them accurately. If you use linear shading, keep it in one direction; form is shown by the correct intensity of the mark, and subtle variations in tone are the best way to imply contours.

USEFUL AIDS TO DRAWING CONTOURS

Stripes, checks, plaids, and repeating patterns on garments may seem like unnecessary complications when drawing, but they provide the opportunity to illustrate contours, as they always turn with the form. If your sitter wears a striped top, the stripes will describe the curvature of the arms and body; plaid slacks show the form of thighs or shins as the pattern curves around the leg. Dots, sprigs, and other repeated designs indicate contours, too, because they are seen in perspective and will be condensed or foreshortened as they follow a form. Patterned hats and headscarves do the same for heads, as does the lettering on sweatshirts or baseball caps. Patterned backgrounds and surroundings, such as upholstery, wallpaper, and curtains, all show contours and angles. Shelves, window bars, and blinds provide a built-in reference grid that helps define the proportions of figures seen against them.

The stripes that run across the knitted hat in this sketch reveal its contours with economy. They also provide an elegant solution to the problem of describing its surfaces; always be on the lookout to include such contour aids.

SHAPES AND TEXTURES

Landscape is composed of shapes within shapes, from the broad levels of the land to dominant features such as rocks and trees to the delicate details of foliage and flowers. Form and texture in a landscape image are developed out of concentration on the relative scale and complexity of these different elements.

However detailed your drawing, it is inevitably an approximation of what you actually see – no one draws every leaf or every blade of grass, and even the major forms acquire some modification as you translate them into a two-dimensional representation. The choices made in

selecting particular aspects of the subject and working out ways of interpreting them technically are the ingredients of an artist's personal style.

This selective process means that it is important to find those things that most effectively describe the character of the subject and convey your special interest in it, whether they are generalized forms or specific textures. Because colored pencils allow you to work up an image slowly, you can make continuous adjustments and focus quite precisely on the elements of the landscape that you wish to bring out.

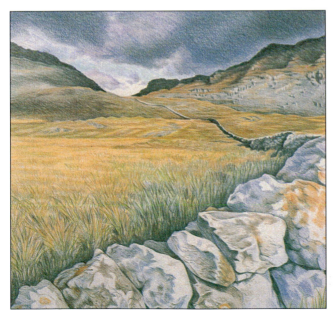

STONE WALL
BY JO DENNIS
The wall forms a curving line, leading the viewer right through the space of the picture and effectively cutting the composition into two parts. The focus on the large stones in the foreground startlingly enhances the perspective. These interlocked shapes contain an interesting pattern of smaller shapes within.

PATTERN AND MOVEMENT

Apart from their enjoyable decorative qualities and their role in describing form, emphasizing pattern and texture is one of the best ways of organizing a complicated subject.

Pattern and texture create much of the surface interest in the forms you draw; if you decide to feature them, you must choose beforehand how you will treat them. The choices range from the literal and anecdotal, which is decorative but laborious to execute, to the impressionistic, where key qualities are rendered in a simplified way. Use lighting to assist you in heightening or simplifying effects: for example, a raking light shows up texture to advantage, while heavy cast shadows obscure large areas of busy pattern.

Choose media that depict different aspects of pattern and texture well. Pastels and carrés make crisp marks to represent the complexities of

pattern, and have the breadth required to achieve a range of different textural effects. Pen work is a source of varied, expressive marks to depict texture, and has the flexibility necessary to render any patterned effect, from brash to fine. Charcoal has the advantage that it can be easily erased if you need to adjust a tricky pattern, and graphite, the perfect flexible medium, can convey both patterns and texture with subtlety. If you have any difficulty in deciding what to show, stop drawing and look carefully until you have devised the right response to render the effect you want.

One possible approach is to base your response on your natural vision. Wide areas of pattern or texture are not seen needle-sharp but more generally, with smaller areas that are seen more clearly when they are in your main field of vision. The

EXOTIC FISH BY CARL MELEGARI
The use of soft-textured pencils on smooth paper gives the colors a brilliantly clean, jewel-like quality appropriate to this subject. The strong directional quality of the line work creates both solid form and an atmospheric, watery background.

field of vision we see is cone-shaped, with the center of the cone in sharp focus. At arm's length, the focused area is only the size of a thumbnail. In order to see clearly on a wider scale, you scan constantly from a moving vantage point, not stock-still.

Because peripheral vision is vague, pattern and textures away from the center of interest can be dealt with more broadly. It is not necessary to attempt to convey every detail of a complicated texture or pattern to achieve representative effects, but a vignette with blurred edges can lack credibility. Select what you want to emphasize in conjunction with your three-dimensional design, and remember that areas of pattern and texture that are developed in detail will become eye-catching centers of interest.

LINE AND MOVEMENT

Rapid line drawing is useful for capturing movement. With practice in coordinating your hand and eye, you will draw faster and more confidently. Visual memory gets better with use, and by looking hard at motion you can fix the characteristic shapes in your mind's

A racing greyhound is caught in midair. A sense of movement is created by the sensitive broken lines and dancing tones that animate the wave-like undulation along the muscular body.

eye, drawing from the split-second memory. Alternatively, make composite drawings by gathering features from several moving elements. This method shows no one subject, but has the plausibility of observed action.

There are too many exciting subjects that involve movement for you to avoid drawing it for long. Success depends on a positive approach, so build up confidence by starting with slow and simple, repeated movements: a tethered flag, or laundry blowing in a stiff breeze, is a good example of an inanimate subject to begin with. Try drawing a friend or relative at home. Preparing food, digging a vegetable garden, or working at a computer are all activities that involve small-scale, repeated movements by a subject who will return to similar positions time after time.

STYLE

Your artistic style should be personal — watching others can reveal useful techniques and approaches to a project, but this is of limited assistance, because style cannot be adopted secondhand. The ways to develop a personal style include maintaining an original and innotive response to what is seen, together with the choices of appropriate techniques, design selection, tone and color organization, and experimenting with new ways of mark-making to create an image. When you recognize your own style emerging, you can adapt it by adjusting the choices you make.

In developing your own style, there is no need to seek out the extraordinary or bizarre as a way of creating something new, although in the course of your progress, you may come across a vision so compelling that you want to interpret or record it. Until you are sure of your preferences, turn to the evergreen subjects that preoccupy artists — still life, landscape or townscape, and portraiture. These are reinterpreted by each new generation because they are full of interest, within easy reach, and lend themselves to an individual approach.

The subjects may be standards, but the new factor is you, with all your characteristics, aptitudes, and persuasions. You are the person who makes the drawing, so reflect your unique combination of qualities with an interpretation based on your personal choices. Let others influence your work, but as an inspiration, not a stylistic restraint.

There is no need to strive for self-expression as you work; your artistic identity will emerge, almost of its own volition, perhaps to surprise you, as you concentrate on the tasks at hand. Be brave enough to follow your intuition if you feel impelled to draw in a certain way. Following this prompting will result in progress, because your instincts are your best guide to developing your own unique, personal style. The drawing that results may not be a complete success, but contained within it will be the harbingers of future work, and technical innovations to build on for a new approach.

It is through such efforts that skills are increased and new ground is broken. Your discoveries will be original, whatever your stylistic approach, and will enable those who look at your drawings to see the subject through your eyes.

In the following pages there are examples of drawings from some of the Great Masters, from John Constable and Leonardo da Vinci to Michelangelo and John Ruskin.

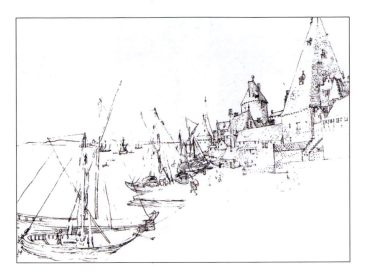

HARBOR ON THE SCHELDE BY ALBRECHT DÜRER

This very fine line drawing is precise yet economical. The solidity of the forms is realized with sparing touches. Each shape is related most carefully to all the others in such a way that the whole image acquires a unity that is more than a sum of parts.

VIEW OF WIVENHOE PARK BY JOHN CONSTABLE

Constable demonstrates here how much can be achieved with the pencil alone. The forms of the landscape are firmly established in space, but also the quality and texture of each part is given due weight. The cornfield in the foreground has its own character defined with the simplest of means, and the delicate treatment of the sky is equally sensitive to light and texture.

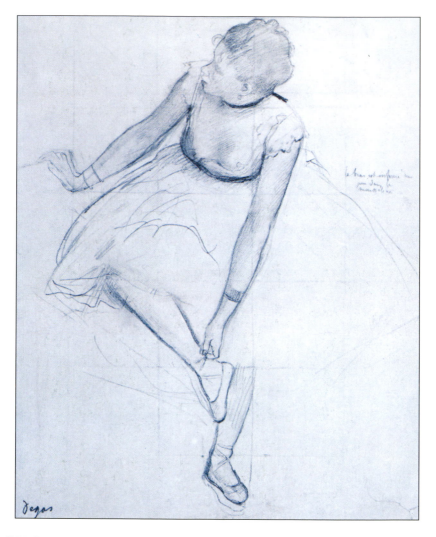

DANCER ADJUSTING HER SLIPPER BY EDGAR DEGAS

The studies of ballet dancers by Degas invariably capture an immediacy that is crucial to the subject. This pencil study vividly recalls his vibrant pastel drawings, but has its own formal qualities that show an understanding of this delicate medium. Nervous lines trace the outline of the form and the various visible alterations express the rapid observation of the whole form necessary when an artist must extract the essence of a fleeting pose. As the eye moves over the subject, the pencil swiftly records the impressions. Added emphasis in certain lines and judicious use of tone fix the angle of the body.

PAGANINI BY JEAN AUGUSTE INGRES
This portrait was drawn during the artist's stay in Rome, where he moved in 1807 after winning a scholarship. It may have been one of the portraits he made – chiefly in pencil – to earn his living after his prize money ran out. Ingres, who had studied in David's studio, went on to become one of the best-known French artists of his day and was firmly identified as an opponent of the new Romantic movement. At the time this portrait was executed, Niccolo Paginini (1782–1840) was on the brink of success as a virtuoso violinist and composer. This portrait shows Ingres's sensitive draftsmanship, yet displays a paradoxical realism. The entire figure is observed in detail, but the twisted pose and recession in space imply that the sitter is viewed from a distance.

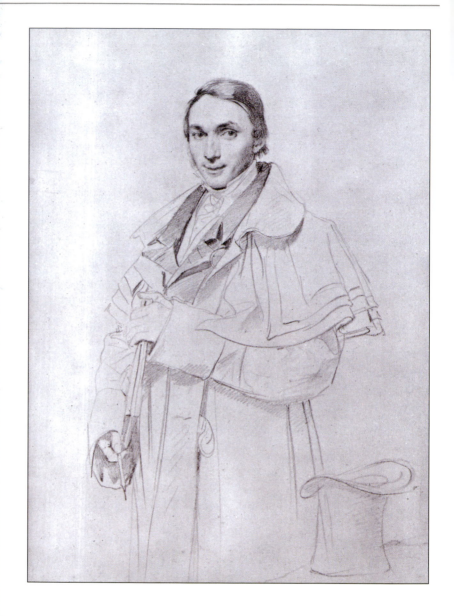

PENCIL STUDY BY JEAN AUGUSTE INGRES
Ingres was extremely adept at simple pencil studies of this sort. Using only a rough outline and areas of shading, Ingres captured his subject with economy.

DORELIA IN A STRAW HAT BY AUGUSTUS JOHN

This pencil drawing is typical of this artist's approach to the female figure. The multiple folds of drapery enhance the elegance of the classical pose and although it is a full length view, the facial features are noted sufficiently to give a portrait of the expression and style of the model.

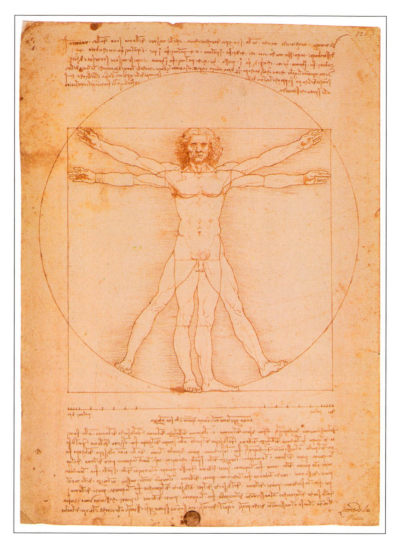

SKETCH OF THE PROPORTIONS OF THE HUMAN BODY (FROM *DE ARCHITECTURA* BY VITRUVIUS) BY LEONARDO DA VINCI

Leonardo's drawing shows his age's concern to determine systems of proportion, and the attempt by the architect Alberti (1404–1472) to assert a link between primary and geometric form and those of the human body derived ultimately from Plato's statement in the Timaeus that the universe was built up from geometric solids. By containing the human body within a circle, Vitruvious was also affirming its divine proportions, the circle being the symbol of divinity or perfection.

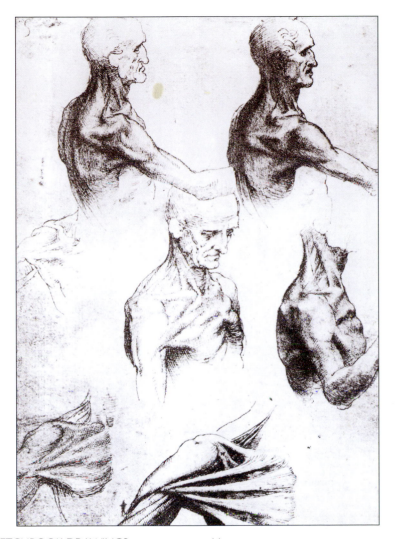

SKETCHBOOK DRAWINGS BY LEONARDO DA VINCI

Leonardo da Vinci conducted extensive research into the human anatomy and his confident, realistic studies remain both anatomically and aesthetically interesting for the twenty-first century student. The head of the subject portrayed here is well placed on the shoulders. The most visible of the shoulder and chest muscles is the pectoralis major, which is attached to the clavicle and the sternum and looks like a fan when outstretched. It attaches at the other end to a point beneath the deltoid muscle on the arm. The trapezius is the muscle that runs down the back of the neck and attaches to the upper spine at the back and to the clavicle at the front of the torso.

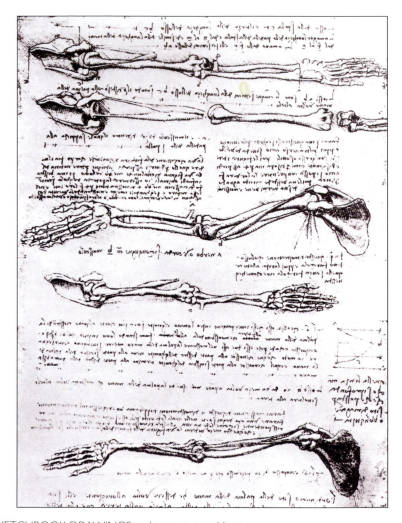

SKETCHBOOK DRAWINGS BY LEONARDO DA VINCI

This extraordinary artist and scientist filled a great number of notebooks with observations and drawings of the human anatomy, sometimes carrying out dissections to increase his knowledge. The precise drawings on this page describe the bones and joints of the human arm from both sides. The shoulder blade, or scapula, and shoulder are attached to the humerus of the upper arm by a ball and socket joint; the humerus attaches to the bones of the lower arm, the radius and ulna, with a hinge and joint which allows great flexibility. The carpal bones of the palm of the hand are jointed to the lower arm and extend into the metacarpals and phlanges of the fingers. All Leonardo's observations are supported by notes in his curious mirror handwriting.

WOMAN'S HEAD

BY PABLO PICASSO

This gentle profile study has shallow tonal modeling inside the form and darker tone in the background, which brings the profile foward as if it were a low relief. This use of tone is not intended to give a realistic impression of form, but is an extension of the linear drawing.

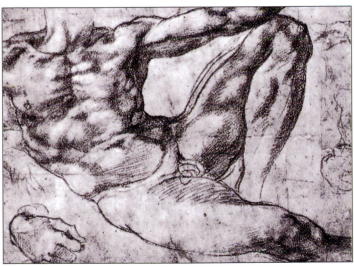

This is Michelangelo's study for the torso of Adam, which he drew in preparation for his work in the Sistine Chapel; although Michelangelo had a profound understanding of anatomy of the human figure, he never let this knowledge get in the way of his artistic expression. In the finished work, where Adam's hand is receiving a bolt of lightning from the hand of God, the anatomical detail has been reduced to a minimum so that the eye is not distracted.

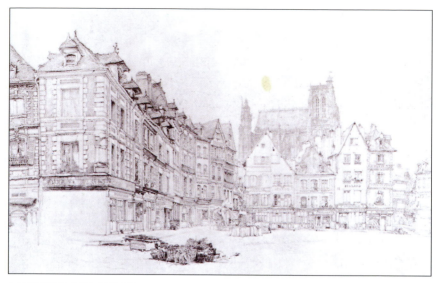

MARKET PLACE, ABBEVILLE BY RUSKIN

Here, Ruskin's drawing employs a combination of the accurate linear perspective of, for example, Canaletto to depict the foreground buildings and the blurring of the more distant buildings which is one of the devices and conventions of atmospheric perspective.

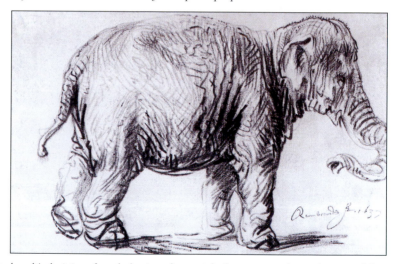

Rembrandt's depiction of an elephant employs a style that expresses the rough power of the creature. A network of calligraphic lines and loosely hatched tones arrests the movement and suggests the strange, furrowed texture of the skin.

A PATH BORDERED BY TREES BY RUBENS
Rubens has used fine, detailed line and stipple together with background washes to achieve a quality that is almost ethereal.

SUBJECT

Many people approach drawing with preconceived ideas about what makes a suitable subject. Any and every subject is capable of providing the inspiration for exciting drawings.

There are many theories about how artists should be trained. Some teachers believe that students of drawing should use pencil exclusively until competence and flair are well established. On the other hand, however, one could take the view that because drawing is fundamentally concerned with seeing, the use of a variety of media is necessary to stimulate the imagination and avoid getting into a rut. All artists need to develop their skills, learn new techniques, and experiment and use them to make drawings of as wide a range of subjects as possible.

Everyone has the capacity to find in any subject something that is uniquely significant or meaningful to them, and it is this ability that makes every person a special kind of artist.

STILL LIFE

To elicit a personal response, consider your involvement with the objects that comprise your group.

A good starting place for selecting objects for a still life would be the things on your own kitchen table, because they are closely associated with your daily life, even if you make nothing but coffee at home! The more bound up you are with the objects, the better you will draw them, because by looking at them with real interest, you will observe them well.

Add to the impact of your work by selecting a group that has a recognizable theme. This can be based on anything: natural forms, the geographical or ethnic origins of the items, a philosophical idea, or a single factor such as the color of the objects. A few items and a simple set-up should be sufficient.

Make sure that your objects and their setting are chosen for their varied visual qualities – try glossy and rough, transparent and opaque, or round and angular. Look at the overall shape of the group, and judge when to balance low things with a tall one.

A frequently used still-life device is that of placing an ordinary object in an unconventional way. We would expect to see the sauce container standing on its base, but the artist has chosen instead to represent it lying on one side. Such manipulation can impart a feeling of unease in a drawing. It can appear as though the elements of the composition have been disturbed by some outside force. Here, this feeling is enhanced by the realistic, almost photographic, drawing technique. The cup and gravy boat are built up with areas of carefully graded tone, which clearly describe the smoothness of the surfaces, the fluting around the cup, and the delicate form of the gravy boat. There are no outlines but, by careful selection and representation of light and dark areas, the artist has created a highly naturalistic interpretation of the objects.

MAKING A MONOTONE DRAWING

1 Make preliminary studies of forms and textures, and a thumbnail sketch of the kitchen table. Explore texture qualities such as transparency.

2 This view has the overall shape of a triangle, resting in a broad base – a stable but weighty framework that, without the space created by color, needs to be livened up. By making an interesting arrangement of the folds in the table covering, you will create more dynamic movements through the three-dimensional design. The cloth links the objects with curvilinear shapes, providing a good contrast to the dominant, straight forms of the bottles. Draw the lines and tones of the basic composition freely with a graphite stick, and evaluate and adjust them rapidly.

3 Circular items cannot have sharp corners, so examine any ovoid shapes, such as the surface of the liquid in the bottles, and ensure that the extremes of the ellipses are tightly curved turns, not angular, such as the bottles, by working across them

and recording the evidence of solidity, including the tonal information. By developing them as three-dimensional forms, you will be able to keep them symmetrical. When the overall structure is established, reinforce the darker tones with the graphite stick.

155

4 To sharpen the definition, use a pencil of the same grade as the graphite stick, or close to it. Wide differences in grades allow the softer and blacker to dominate, effacing those that are harder and more silver-hued. As you define your objects and their surroundings, make use of the opportunity to develop the subtleties of the three-dimensional design. Decide by observation which of the linear movements through the two-dimensional plane to emphasize, and which tonal contrasts to increase almost imperceptibly, to organize the visual progression around the group.

5 The aim now is to resolve the solidity of each element. Much of the information that makes the items palpable is tonal; develop the tone evenly, so that you can compare the relative strengths. Avoid working on fragments or isolated "islands" of tone – these are unconsciously compared to the remaining white paper, instead of the adjacent values. Enrich the tonal scheme steadily by even development; stand back frequently to assess the relationships throughout, and determine the depth of tone required by half closing your eyes and peering through your eyelashes.

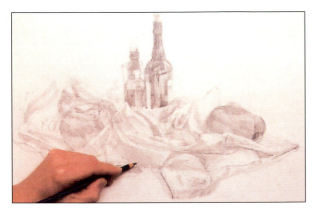

6 When the forms appear to be tangible and to possess weight and density, consider the details of their surface appearances, because these depend on the different substances of their composition. Differentiate between the glossy shine and the polarized tonal contrasts of glass, and the delicate sheen on the raised folds of the cloth. The vegetables reflect light yet another way, from the pearly nature of garlic bulbs to the polished shine of dried chilies. Devise the subtle marks that will render these different qualities appropriately by direct observation.

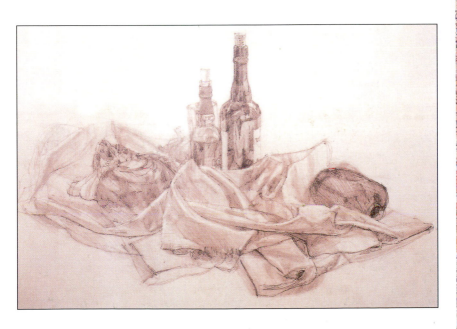

KITCHEN TABLE BY JODY RAYNES

157

BACKGROUNDS

There are times when a still life is found completely by chance. A number of objects are discovered miraculously grouped in a way that will make a good picture. In such cases the background is already there, and consequently there is no need to drape fabric behind the found group or use any other device to separate it from its surroundings. When a still-life group is deliberately composed, however, during an art class or in the artist's studio, it may be necessary to create a background. Convention, on these occasions, prescribes the use of either flat sheets of board behind the group, so as to give the appearance of a wall (or sometimes two walls meeting at right angles) or draped fabrics. Although draped fabric has become something of a visual cliché in still-life painting, nevertheless it can give an interesting contrasting texture to the objects in a still-life group, and if it is draped in folds, the material provides a useful background reference for drawing accurately.

But the background of a still-life painting is usually of limited importance and sometimes is reduced to negligible proportions. This depends on how large the still-life objects are in relation to the picture and on the viewing position taken. If the group is painted by an artist standing at an easel where the viewpoint is high, the background becomes the surface on which the objects are placed. Even when the objects are carefully selected and positioned it is often unnecessary to make a special background. The unfocused view of the room or studio where the objects are may be a perfectly acceptable foil to the still-life group.

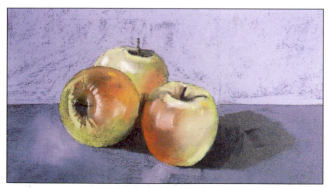

This delicately simple pastel drawing achieves a certain drama despite a flat neutral background. The drawing's impact is achieved entirely by the effect of the three apples. The blends of red and green, together with the touches of white gouache for highlights, conspire to give the apples a vivid three-dimensional form. The shadows and reflections of the apples help to qualify the setting and assist in defining the space.

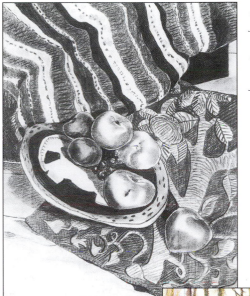

Although this is only a detail taken from the charcoal original, it demonstrates how the complete drawing succeeds without a definite background. The viewpoint is high and the striped fabric behind the plate with the apples extends beyond the top of the picture. The drawing concentrates on pattern; the contrasting patterns of the fabrics and the configuration made by the print on the decorated plate. Although the drawing is to an extent more concerned with the compositional pattern created on the two-dimensional surface, rather than the three-dimensional space, the apples and grapes have been modeled with highlights to demonstrate their round shiny quality.

Such a conventional group – a wine bottle and fruit placed on a crumpled tablecloth – has been given an unusual twist by the choice of background. The feeling of space in the drawing has been largely created by the difference in scale between the still-life objects, the window frame, and the background buildings. A brush and watercolor paint have been used to produce lines of color as one might do with pastel or crayon. With the main shapes of the composition established in this way, color was laid over the top, mainly in hatched lines. The still-life group has been described in dark outline, with highlights on the reflective bottle and the fruit to emphasize the plastic form of these objects.

MAKING A COLOR DRAWING

A still-life arrangement can be an excellent vehicle for the study of color, shape, and structure. The still life may take any form from the traditional subject of fruit and flowers to a jumble of objects randomly selected from whatever is at hand. Choose objects that offer an interesting pattern of forms; develop contrasts and harmonies in the range of colors and between geometric and irregular shapes.

The final effect of this drawing is created by successive overlaying of lines in different colors, woven together to create a range of subtle hues. Each layer is described by lightly hatching and cross-hatching to gradually build up the overall effect. Blue and purple form rich, deep shadows in the yellows; a light layer of red over yellow warms up the basic color without overpowering its character.

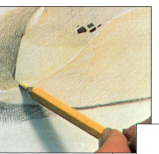

Subtle color tones are created by overlaying light strokes of color. Here the artist works over a shadow area with a light yellow pencil.

1 Lay in a block of light blue shading behind the hat, varying the direction of the pencil strokes. Use the same blue for shadows on and around the hat.

2 Strengthen and broaden the background color. Develop the shadows and pattern details of the hat. Draw in the shape of the boxes with yellow and red pencils.

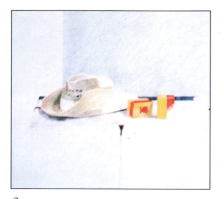

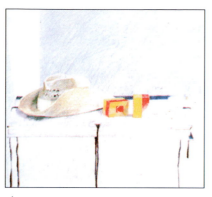

3 Build up the colors with contrasts of tone. Use purple in shadows under the hat, and darken blues to make the objects stand out from the background.

4 Outline the portfolio and sketchbook in black. Strengthen the bright colors against the neutral grays. Lay in the rest of the background area in blue and vary the tones by heavily reworking. Build up details of line and tone with black and yellow ocher.

The finished picture illustrates how colored pencil may be used to create a subtle, atmospheric image. The combination of soft tones with a strong composition create a balanced and interesting image.

PLANTS AND FLOWERS

Varied textures, colors, and shapes all make plants and flowers one of the most attractive and challenging artistic subjects.

FLOWERS

When drawing flowers, the spectrum of what you can draw ranges widely; you can choose to create a simple study of a single flower, or, at a more ambitious level, you might decide to draw a complex, sprawling ivy, or a complicated flower arrangement. Whichever you choose, remember that plant drawing is a mixture of still life and natural history. Obviously, you can set up many subjects in the studio, but, at the same time, you should never forget that what you are drawing is a living thing and should be rendered as such. One of the best things to try is putting the plant – your main subject – into the most natural setting you can find. The surrounding colors will frequently make the final study more sympathetic.

Pencil is the ideal base medium, since its use will enable you to achieve high standards of draftsmanship. The tool gives you the ability to capture the intricacies of detail and so analyze the problems of shape and form. Make the best possible use of the chosen support, allowing the plant almost to "grow" upward and outward across the surface. Use color sparingly, but decisively, making the fullest possible use of the resources of mixed media. A slight descriptive touch of local color, for instance, can enliven the study of something as simple as a rose twig.

1 Start by drawing the basic forms of the main flower, trying to get the effect of the radiating petals. Work out the tones of the inner forms; they are complex and must be very closely observed.

2 Be certain to make the smaller flower relate spatially to the one above. Draw in the stems and leaves, making a definite contrast between the fairly simple forms of the leaves and the complexity of the flowers.

3 When drawing the attendant blooms, keep them simpler and use a straighter, more linear technique so that they have less tonality than the foreground head and recede in comparison.

TULIPS BY ANGELA MORGAN
The complex arrangement of petals and leaves that forms the composition has been keyed with a faint pencil outline, and although the overall effect is light and fresh, the pencil colors have been laid in with a confident, free technique.

163

POTTED PLANTS

Potted plants are often accessible when other plants are not, and can provide some stimulating composition ideas. With a large plant such as this, a single leaf can form the basis of a drawing. The strong greens were built up with pastel, rubbed firmly into the paper, one layer superimposed over another. The circular mirror adds an unusual and interesting background of reflections and light. Detail has been kept to a minimum so that the arrangement of large simple shapes, boldly blocked in with color pastels, is not compromised.

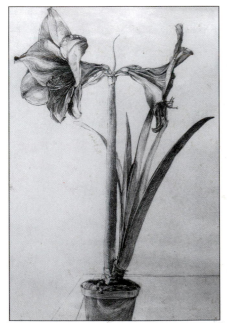

A common difficulty in flower drawing is how to describe the three-dimensional form of the petals clearly and yet ensure that their unique texture is retained. To solve the problem the artist has differentiated, in this pencil drawing, between the textures of the stem and leaves and that of the flower petals by using a different shading technique and by varying the quality of the line. The stem and leaves are shaded with short crosshatched strokes, capturing the firmness of their form. By contrast, the flower petals are shaded with longer, curving, more gentle lines. In this way the contours are clearly described, yet the soft pencil line also expresses the delicate texture.

FOLIAGE

Leaves are just as various and appealing as flowers, although at first sight their color properties may seem less rich in scope. However, part of the skill of working in colored pencils is learning to control subtle nuances of color and to form complex color blends and mixtures by building up and overlaying your range of individual hues. The subtle changes of hue and tone within the range of foliage greens provide an excellent means of developing and testing your skills in this direction: hatching, shading, and stippling are all

potentially valuable techniques, and in studying the intriguing shapes and textures of different kinds of leaves, you can learn to exploit the full range of your pencils' line qualities.

Indoor plants are ideal subject matter, especially as many foliage houseplants are tropical and sub-tropical species with strong, fluid shapes. The colors of variegated leaves also add to the variety of your resources. Outdoor locations – gardens, parks, or the open countryside – provide plenty of inspiration.

EUCALYPTUS BY STEVE TAYLOR

The leaf shapes are simple forms and so a controlled tonal balance is essential to the complexity of the rendering. The gentle watercolor hues are strengthened with light pencil shading. Where veins and stems show white against the color, the paper is left bare or very lightly painted. A clear guideline is needed, which can be drawn direct or may be transferred from an existing drawing or photograph.

BOTANICAL DRAWINGS

The finest botanical drawings are works of art by any standard; nevertheless the aim of the botanical artist differs from that of the artist who draws flowers for their pictorial qualities. The latter is not concerned with a precise, literal description. The flowers may only be suggested in the drawing, or they may appear as a few indistinct patches of vivid color against a neutral background. In botanical drawing what matters is that the flower or plant be explained in all its detail. This sometimes involves the inclusion of written notes alongside the drawing or accompanying close-ups of distinctive petals, for example, or leaf formations.

To position flowers for botanical drawing, you should pay attention to shape and construction. Generally only one species is selected as an individual study, but depending on the type of flower, a stem with two flower heads or blooms at different stages of development may be needed, so that two different characteristic views of the flower can be represented. It is difficult to prevent botanical drawings from appearing flat and lifeless because the artist conceives his or her work primarily as a scientific study of the object with all its features shown and explained so that it can be used for identification purposes. It must remain, therefore, uncluttered by unnecessary background information.

This is one area of drawing in which detailed knowledge of the object is a great advantage, and a sound knowledge of botany, along with painstaking observation and attention to detail, will produce the best results.

A detailed pencil outline was the first stage of this small drawing. Once satisfied with this, the artist blocked in the main colors and areas of shading with aquarelle pencils. Then, taking a small sable brush and clean water, she dissolved the applied color and blended carefully. By repeating the same procedure a number of times, the artist built up strong layers of color. Aquarelle pencil used in this way makes it possible to build up beautifully subtle transitions of tone and color, as can be seen where green turns to brown on the large leaf.

This inspired worksheet of drawings was the result of close scrutiny of the individual parts of the plant. Pencil is ideal for this type of botanical study, as it can be erased and corrected with ease. The color information was added to the drawing with a small sable brush and watercolor. Many artists make written notes as they go along in order to help them remember not only the peculiar characteristics of the plant, but also the colors and quantities used to mix the exact tints and shades.

FLOWER STUDY • COLORED PENCIL

Among a bunch of mixed flowers, the artist found this freshly-cut golden-yellow lily. The perfection of the large supple flower head seemed to warrant individual study. Placing the flower on a white surface, the artist set to work immediately with colored pencils. To make the most of the pattern created by the beautifully colored petals and ornate anthers, the artist decided to fill the paper with a close-up of the flower head. The choice of a high viewpoint means that the leaves, stems, and accompanying single bud combine to create an arresting and decorative linear design.

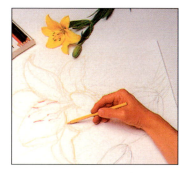

1 Pale contours and outlines of the flower, leaves, and stem are sketched in with corresponding local colors. The artist studies negative and positive shapes, keeping the drawing fairly loose to allow for adjustments as the image develops.

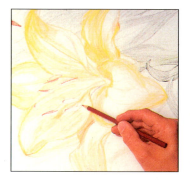

2 The mid-tones are now added and more colors introduced. Two different yellows and oranges are mixed to describe the subtle nuances of the petal color. Capturing the soft texture of the petals is of paramount importance and this is successfully achieved with languid strokes. These contrast with firmer hatching on the leaves.

3 The artist begins to build up the rest of the drawing. The composition focuses on the flower head, which consequently is represented in brighter detail, but the leaves and stem play an important decorative role. The dark, linear patterns of the leaves and their shadows set off the delicate mass of yellow petals. Colder colors and deeper tones strengthen the shadows.

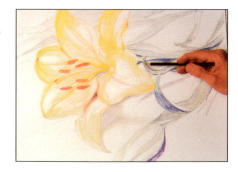

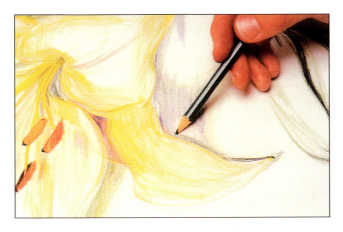

4 Finally, a black pencil is used to pinpoint dark areas, which provide necessary contrast to enliven the drawing. Note the shadows cast onto some petals from the anthers. This well–observed detail adds an important sense of space (below).

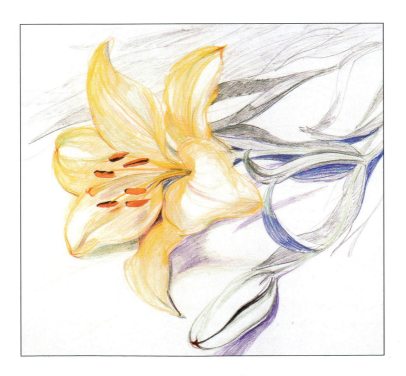

LANDSCAPE

We are all affected by the landscape around us; it has a profound influence upon the way we live and our view of life. We appreciate it not simply through our eyes, but with all our faculties; the changes of weather, wind, sun, the night, and the dawn all become a part of our experience.

All the elements of the landscape have combined over the centuries to form an intrinsic part of the artistic tradition, together with the different reactions each individual view produces. This occurs on two levels. The apparently limitless horizons of moor and downland, or the sea, obviously encourage different reactions to those produced by the harsher lines of a dense cluster of buildings. How these reactions are interpreted, however, totally depends on the nature of the artist. He or she can produce a romanticized view of a rural landscape, or a dour and somber one of a townscape; equally the townscape could be approached romantically and the rural scene more realistically.

What you should aim for are inventive and surprising angles, views and atmosphere. Edward Hopper's New York rooftops, for instance, differ from the landscape etchings of Rembrandt, or the sketchbook drawings of Turner. Start with a familiar subject and look at it in the most concentrated way possible, even before making a single mark on your support. This kind of concentrated consideration will often surprise you

and your eventual drawings can only benefit as a result.

As you explore the possibilities, you will find that landscape is a subject with many advantages. It stays still, except when blown by winds or lashed by storms! It can take on many different and interesting moods. Light moves across fields and trees, for instance, to bring rapidly shifting relationships of tone and color. Skies, which are sometimes thought to be the single most important feature in a landscape drawing or painting, also vary widely. They can range from leaden gray, dark, and threatening, against which features stand out as bright and highly contrasted, through the huge, cloud-filled variety to a bright, clear backdrop to rich foreground detail. Never fall into the trap of disregarding the sky, or relegating it to the status of insignificance.

Bring this same perception to the question of color. Green is the dominant color of landscape, but it is easy to make it thin and acid. It requires real sensitivity to achieve an effective, living, vibrant foliage, or grass, green. You can only achieve this by constantly varying the range of

color with which you are working; no single green can possibly reproduce accurately the range of colors seen in nature.

Each element of a successful landscape will have the same degree of careful consideration brought to bear on it. Here, associations and identifications are likely to be involved and decisions made accordingly. Wind, for instance, causes movement. It bends trees in the direction in which it is blowing, while the sky will generally be light in tone. Therefore, all parallel surfaces, such as lakes, fields, and rivers, will tend to be light. Objects standing against the sky – vertical forms such as trees and buildings – tend to be dark. Use such simple, basic guidelines to help you select a viewpoint and a theme, or subject.

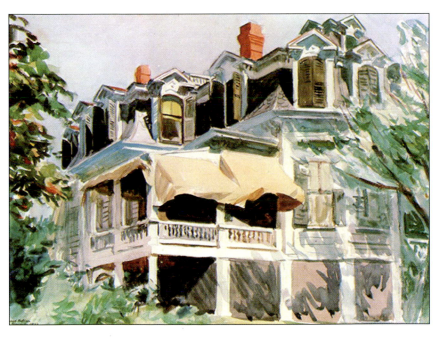

THE MANSARD ROOF BY EDWARD HOPPER (1923)

SEASONAL VARIATIONS

Perhaps the most appealing aspect of a landscape as a subject is that it is constantly changing. The seasons and the different weather conditions associated with them serve as an inexhaustible source of visual stimulation. Strong summer sunlight fills a landscape with color and dark shadows, ideal for a pastel drawing. The same view, when snowbound, could provide the artist with the perfect subject for a calligraphic black and white brush drawing. Storms can transform a placid scene into an arena of contrast and drama. Rain and wind create movement as they travel across a view, perhaps transforming a static leaf-laden tree into a dynamic feature yielding to the unseen force.

To capture the effects of weather, it is best to work outdoors immersed in it. Sound and smell are often overlooked as important elements in our experience and understanding of

weather. Try to push the medium used to its limits, so that the actual substance of the drawing reinforces the subject. A charcoal drawing of a storm might be handled so expressively that it develops a patina, as if weathered itself; a delicate loose line and wash drawing might appear to tremble as if laid down by a gentle breeze.

Three studies of the changing seasons of the year explore the changes in the physical landscape as well as tonal variations. Colored pencils and a variety of hatching techniques help to record the changing contours, colors, and tones.

The tonal contrast is high in the bright sunlight of the picture opposite. Above, the same scene is viewed in the subdued light of a dull winter's day and the contrast is reduced. Note also the change in the basic shape of the landscape. In the drawing below the soft leafy hedgerow is captured in its bare wintry state.

LANDSCAPE IN PENCIL

The tonal characteristics of a landscape can alter dramatically as seasons, weather conditions, and time of day change. Drawing the same view at dawn and dusk can produce very different results, due to shadows and light sources shifting. It is important to work quickly so that you can record the light at one single moment of the day with accuracy. A wide variety of tones can be achieved with the sensitive adjustment of touch, marks, and shading available from a single pencil, and with the use of an eraser to expose the paper's white surface. Find a viewpoint that provides an interesting blend of light and dark features to create a lively and contrasting scene.

1 Starting from the center of focus – in this case the tower of a chapel among trees – outline the main areas. This needs little more than the line created by the weight of the pencil on the paper. Applying too much pressure now can cut down the range of tones you may need to call upon later, leaving the overall image too dark. As you work, emphasize these light touches when you are satisfied with their position.

2 Keeping the pencil sharp – turn it in your hand every few minutes to maintain a point – work on some of the lighter areas, such as the sky. There is a surprising variety of tones here, too, and by using the side of the pencil you can create a contrast with the foliage. The trees can be created from a series of small marks, rather than by shading. Aim to find marks that are recognizable as different species of trees.

3 The central band of olive trees requires soft marks to make it stand out against the darker trees behind. The hills are lightly shaded in the background. Stand back from your work at regular intervals, to get an overall view. Light conditions and cloud formations will change if you are working over a period of hours or days, so do not commit yourself to dense tones too early in the drawing.

4 The tonal values needed in different areas become more apparent as the picture develops, and you will find it necessary to return to areas that you have already worked on to make adjustments. The darker tones around the clouds in the sky can be picked out with soft shading that leaves no sign of individual pencil marks. If you are right-handed, you will find that working across the

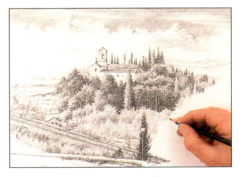

paper from left to right will help to prevent smudging with the back of the hand – and vice versa for left-handed artists. Then develop darker areas to create a sense of depth, see finished drawing below.

SAN VITTORE, TOSCANA
BY MARTIN TAYLOR

ATMOSPHERE

Imagine a hot sunny day in a small New England town and then a similar day somewhere in the Mediterranean. Although the weather may be the same, you would expect the atmosphere of each place to be completely different. Many artists choose to draw a particular place or landscape because of the aura generated by it. It is not the individual elements of weather, the buildings, trees, or people that impress, but usually a combination of all these things and more that create a particular atmosphere. Our own state of mind also contributes to what we perceive. For example, the farmer sees the countryside as a workplace, whereas, to the daytripper out from the city, the atmosphere is usually one of freedom and relaxation.

So how does the artist set about capturing the complex and transient qualities of mood and atmosphere? One approach is to draw the landscape with opposites in mind. Is the mood relaxed or active? Are the characteristic colors warm or cold? Is the air clear or hazy, the view static or dynamic, the lighting dramatic or placid? Analyzing it in this way enables you to build up a broader vision. Combine this with your own emotional response and, through your drawing, you should start to realize the essence of the landscape.

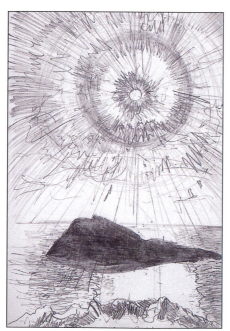

The brilliance of the sun's rays is difficult to capture, particularly if the artist is restricted to black and white. Even if the tonal gradations are painstakingly recorded, the effect is often dull and lacks atmosphere. Here, a more successful approach is evident. Rather than faithfully recording the tonal values present, the artist used calligraphic pencil marks to express the energetic movement of light across the sky, so that the light appears to radiate outward in concentric lines. Dense hatching creates the deep tone of the rock, which contrasts with the highlighted reflection in the water. The result is one of striking beauty.

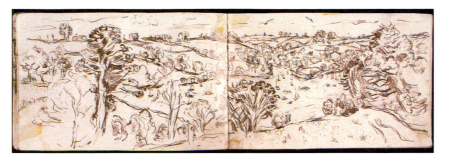

Rambling across two pages of the artist's sketchbook, this view takes the eye across a large river valley, over the hills, and into the distance – without sacrificing the wider field of vision. Sensitive broken lines explore the rhythmical undulations of the hilly landscape. Broader tonal marks, especially in the foreground, add foliage to the trees. The tiny boat shapes on the river are instrumental in creating a sense of scale and therefore distance.

A CORNER OF GREEN BY LAURA DUIS
When describing brilliant sunlight, it is most effective to show a very strong contrast between the lights and shadows. The large hard-edged cast shadow in this picture lifts the pale yellow-greens to create singing tones. These register strongly even though the brightest highlight area is the white front of the bench

WATER

Wherever we live, we all have the opportunity to observe the behavior of water, even if only in the reflections and light refraction caused by a small boy splashing in a puddle, or street lamps reflected in a glistening, wet pavement, or activity in the local swimming pool.

Beyond scenes located close to home, there are ponds, lakes, and rivers of all sizes, shapes, and colors – all affected by the weather and the seasons, while the sea, with its tides and moods, can be strikingly different in Reykjavik, Bali, or Maine.

Many artists choose to live and work by water in order to study it in detail; others have to seek it out, coming across it while taking part in water sports or on vacation. A sailor once recounted how he would watch

for hours on end the churning white water coming from the screws of the destroyer on which he worked, and how this inspired him to paint water subjects. Fishermen, through careful observation, understand the subtleties of currents and eddies in a river and the effect of light on the water, and some take up the brush.

To observe water is not, of course, the same as drawing it. One of the greatest problems for an artist is to look at the world objectively: it is

This is a line drawing of two racing yachts. A full range of tonal possibilities has been used to create the atmospheric depth of a gathering summer storm.

This seascape was drawn using pastel pencil, which is harder than the conventional pastel stick to master, but allows great control over drawing. Pastel pencils do not blend together quite so easily, and subtlety of color is achieved by overlaying one color on another.

too easy to draw what you think is there, rather than seeing what is there. Children think of the sea as blue, and although this is often the case, it is blue qualified by weed and stones on the seabed, sand, and other particles suspended in the water, and white foaming water on the surface, reflections of the sky, and the surroundings. To see things as they are, rather than as we think and expect them to be, takes great concentration. If you can teach yourself to look at water objectively, however, you will have gone a long way toward drawing it well.

Looking at a scene with an artist's eye starts off as an intellectual exercise, with many questions being asked and, hopefully, answered. This cerebral dialogue, which may at first be rather forced, in time becomes second nature – a subconscious exercise. However, you have to work at it, training yourself to look. Observing a stretch of water, you might ask yourself: "Where is the light coming from?," "What quality is the light?," "What is the state of the water?," and "How reflective is the surface?" Your eye will dart around the scene, taking in information about composition and color, and you will be making decisions about possible mediums and techniques.

BUILDINGS

The shape and structure of an individual building may evoke a particular sense of place, or it may draw associations with a personal "narrative" relating to its own function and a suggestion of the lifestyle of people living or working there.

URBAN ARCHITECTURE

For many people, an urban environment is the most familiar setting for both work and recreation. This makes it an immediately accessible subject for drawings, and it may renew your interest in your neighborhood to walk through it with an eye to aesthetic features. Complex arrangements of walls and rooftops and the rich colors and textures of buildings invite interpretation in various media and techniques.

Landscape can be created effectively in monochrome. Here, bulk and the sense of massive distance and weight of the parts involved are the things you should aim to achieve. An archeological site, for instance, is ideal for such a treatment; large standing stones, or deep ditches, will take dramatic shadows, just as trees do in a different context. Avoid the pitfall of sitting square to lines – whether of stone, trees, or hedgerows. Taking a diagonal view can bring additional visual interest, if properly exploited. The composition, too, should be thought of as endlessly changeable, as is the stuff of nature itself.

Obviously, it is best to work on location, whenever possible, though your sketches can serve as a basis for a reinterpretation of the subject in the studio later, if you so desire. Some artists use photographs as visual reference points and certainly the photographic technique of backlighting – used to sharply delineate the silhouettes of trees, for instance – is a telling effect that can form the basis for an inspiring interpretation.

Do not feel inhibited by the conventional approach to media. Graphite powder, rubbed onto the surface to create textures and lay in general tones, is an excellent way of beginning. It is easy to carry and easy to apply, as long as a strong wind does not scatter it from your hand! Use a torchon with it and elaborate on this basis with pencils, or pen and ink. Remember you will need to fix your work with the appropriate spray if this method is adopted.

As far as media are concerned, colored pencils have a special place, particularly when you want to capture the effects of sun and shadow. You can use them to build up layer upon layer of subtle color, the

end result being almost transparent in texture. Pastel also produces surprisingly subtle results and can be blended with the fingers to produce areas of solid tone. Cross-hatching is a valuable foil when trying to achieve differentation in tone and emphasis. When using graphite pencils, a putty eraser is a valuable aid in creating highlights, while pen and ink lends itself to spattering and other interesting effects.

Never reject a possibility as too difficult to tackle. Rain, for example, brings in its wake fresh visual excitement, while the late evening sun, shining red through low clouds, will create interesting long shadows and warm lights. Snow, or mist, will transform even the most familiar of landscapes into something exciting and different.

LUCCA FROM TORRE GUINGI BY RAY EVANS
There is enduring visual fascination in the pattern of interlocking planes, the slanted roofs, and staring walls that compose a townscape. The high viewpoint here provides an overview of the structural logic. Two different kinds of soft-leaded pencil have been used to build up the color areas with gentle emphatic strokes.

MAKING A COLORED DRAWING

1 After sketching in general shapes with a blue pencil, develop general shadow areas with blue and brown pencils.

2 With a pale yellow pencil, begin to put in the lighter areas of the wooden structure. This "underpainting" will ensure a feeling of bright daylight.

3 Put dark areas in with black and dark brown pencils. Cross-hatch using different colors and directional strokes to create color and tone.

4 Work from the center outward to maintain the picture's focal point. Build up shapes using ultramarine blue for the darker areas.

5 Carry the light yellow and ocher tones into the foreground and palm tree. Build up a strong, detailed drawing of the foreground palm with pale and dark green tones.

6 Put in very loose strokes of brown in the middle distance. With a strong stroke, develop the green of the foreground palm. Highlight very bright areas with white.

7 Carry loose, blue strokes over to the foreground to indicate shadow.

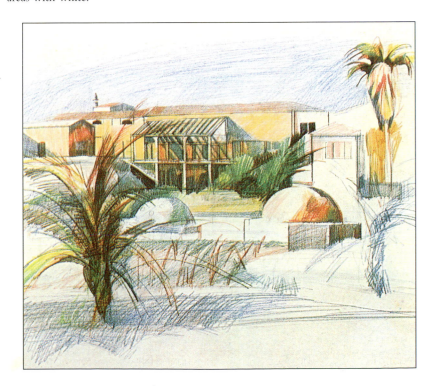

FAÇADES

Concentrating on the façade of a building is like drawing its portrait. The three-dimensional depth and interior space become irrelevant; you focus on the details of the architecture that give the essence of the building's style and make it recognizable and memorable. You have to work out which details contribute to a true likeness of the building as you see it.

Since a direct, frontal viewpoint eliminates many elements of perspective, it simplifies your task in terms of identifying basic structures – but because there is no surrounding detail to distract the eye, the elements of the façade that you wish to portray need to be well chosen and accurately rendered. The accuracy lies not in reproducing shape and proportion correctly as if from an architect's blueprint, but in defining the relationships of shape, form, color, and texture – the ways they interact and how each element functions within the whole. As can be seen from the examples here, this can be dealt with as an apparently detailed, naturalistic image or as a "portrait sketch" homing in on the bare essentials.

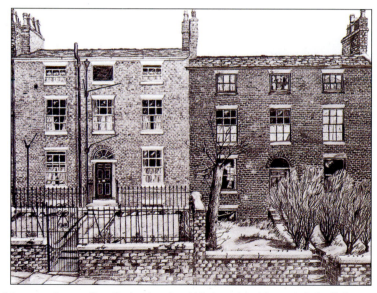

Pencil is an excellent medium for drawings in which the artist wishes to include all the complex details of densely textured subjects. A 2B or 3B pencil can be given a fine point for linear detail, but it is also soft enough to provide a good range of tones.

NAVAL COLLEGE, LENINGRAD
BY RAY EVANS

A complex architectural structure is described in line, with soft washes of color forming coherent surface planes within the framework. This treatment makes the most of the soft textures that can be achieved with water-soluble pencils.

L'ESCARGOT
BY MICHAEL BISHOP

Many clever touches contribute to the detailed impression of this imposing façade. For example, in the brickwork, a very few faint lines serve to convey the overall texture and the cast shadows on the flat surfaces emphasize the detail of the architecture. The quality of the pencil marks is varied to suggest different textures and the organization of color strongly underlines the structural framework.

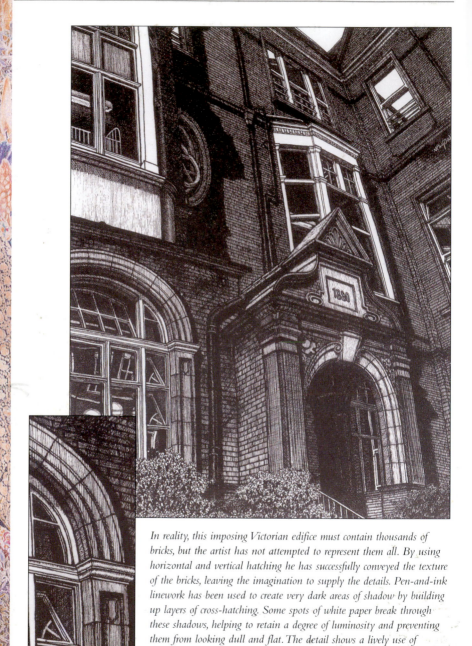

In reality, this imposing Victorian edifice must contain thousands of bricks, but the artist has not attempted to represent them all. By using horizontal and vertical hatching he has successfully conveyed the texture of the bricks, leaving the imagination to supply the details. Pen-and-ink linework has been used to create very dark areas of shadow by building up layers of cross-hatching. Some spots of white paper break through these shadows, helping to retain a degree of luminosity and preventing them from looking dull and flat. The detail shows a lively use of hatching for the stonework of a large window arch.

Colored pencils were used to draw the intricate patterns of these timber-framed buildings. As well as recording surface details, the artist has used light and shade to create solidity and a sense of space. A drawing as complicated and skillful as this one needs to be built up in stages and is the result of careful observation, first of general structure and then of how the details relate to it. The detail shows how the white of the paper is utilized to indicate the window pattern.

THE ANIMAL KINGDOM

*Animals as subject matter for the visual arts have a longer history than any
other subject. The first images drawn by the human race depicted the animals
that were hunted for survival: the prehistoric cave drawings at Niaux (Ariège),
in France, are some of the best preserved examples.*

Lions, tigers, and hippopotami were
frequent subjects for wall paintings in
ancient Egypt and for relief carvings in
ancient Syria. There are numerous
Greek and Roman examples of
animal images in mosaic, bas-relief,
and sculpture. There is no period in
art when animals have not played a
major role.

In modern times, with the
widespread use of mechanical
transportation and with fewer people
working on the land, everyday
contact with animals has become
more distant than at any other time
in human history, so that first-hand
experience of animals for many
Western people comprises the
particular relationship between man
and his domestic pets.

Art has tended to reflect this
change in social conditions. Many
animals are associated with particular
human traits – the courage of a lion,
the infidelity of a monkey, and a
baying pack of jackals are commonly
used as metaphorical images.

The drawing of animals
presents several pictorial
problems unique to the subject
matter. Unlike a human, few
animals obey a command to
remain still. The use of a
viewing-frame or squared-up
paper is thus of little assistance.
Even for a skilled artist the

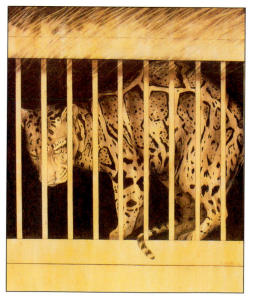

*This poignant study of a big cat in a
small, restricting cage was made with
soft pencil on paper. The bars of the
cage were masked out with tape before
the dense tone of its shadowy interior
was built up. Subtle shading was
needed to portray the leopard's form
and markings.*

Pencil, touches of gold paint, and pale washes of diluted ink were incorporated into this study of a horse's head. The shading was tightly controlled, while the artist studied the sculptural qualities and smooth textures of the subject. The extensive range of tones possible in a pencil drawing is illustrated by the detail (right). Different densities of hatching and careful control of applied pressure will produce both delicate pale tones and rich dark ones.

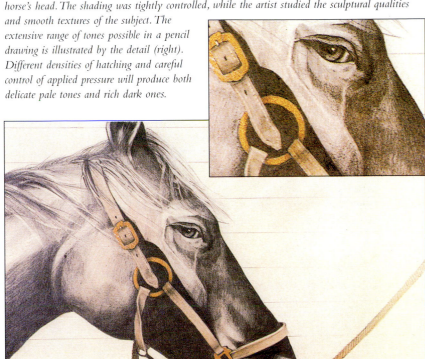

constant movement of a tiger pacing an enclosure in a zoo can present tremendous difficulties. Speed and subtlety of observation are required to draw animals in this environment. Before any attempt is made to put pencil to paper, therefore, observe the animal for some time – how it moves, the size of its head, the proportion and weight of the limbs – and then with the animal in front of you create a drawing that is made as much from your visual memory and imagination as it is from direct representation. When the beginner first tries to draw animals at the zoo, he or she should try to arrange that the time spent there includes feeding time.

LION DRAWING • WORKING IN MIXED MEDIA

Wash and line illustrates the ability of mixed media to capture an image both simply and directly. By a skillful use of line and carefully placed touches of wash, the artist is able to reduce the subject to its bare essentials, creating a picture that is fresh and simple in style.

How to decide upon the ratio of line to wash, and vice versa, takes practice and a keen eye. There are no hard and fast rules but, in general, it is best to keep the image as clear and uncluttered as possible. The temptation to cover the surface with many colors and techniques is a common one; it takes practice, restraint, and a critical eye to put into the picture only what is absolutely essential to best express the subject.

A good reason for resisting the temptation to cover the page is that often the plain white surface can emphasize a line or dab of color far more than any techniques or additional colors can. It is the use of contrast – the broad white or tinted paper contrasting with the sharp edge of a line or subtle wash of color – which serves to emphasize and draw attention to the image. The emptiness and cleanness of a few well-chosen lines and dots of color, when combined with the untouched surface can create an image of eye-catching simplicity.

1 Begin by putting a small amount of gold ocher directly onto a small piece of rag.

2 Rub the gold ocher onto the surface to create general color areas. Use your finger or fingers to draw with the paint and create feathered textures similar to fur.

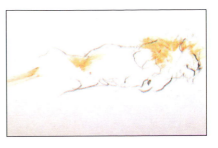

3 With a soft, dark pencil, begin to describe the lion's head over the gold ocher paint. Vary the thickness and width of the line.

4 With the same pencil, continue down the body of the lion with a light, flowing stroke.

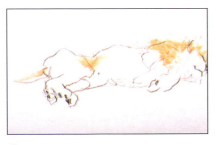

5 Reinforce outlines with more pressure. Put in dark details in the head and feet.

With a dense stroke, the artist is seen here working over the yellow wash to put in the general shape of the lion. See finished drawing below.

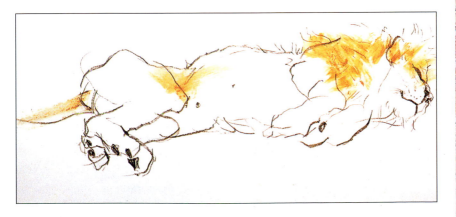

LEOPARD BY KEES DE KIEFTE
*Soft shading builds up the curving volumes in the heavy body
of the leopard, developing naturalistic modeling and rich color
qualities. Small ticks and dashes made with a sharpened
pencil tip elaborate the coarser textures. The whiskers
and clean white patches around the eyes and
muzzle, and the bright fur on the tail, have
been crisply painted with opaque white.*

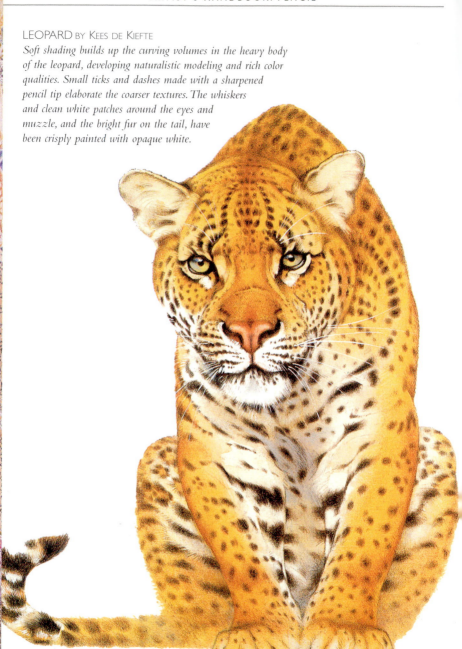

ANIMALS IN MOTION

Although animals move most of the time, they tend to repeat characteristic movements. Cows in the corner of a field will, after moving, come back to the same position and eat in the same way as previously. A pet can often be drawn while it is eating; and birds in cages, or animals in the confines of a zoo often have a sequence of movements that they make around the cage, which enables the artist to depict them in certain characteristic positions.

Drawing animals can be frustrating but with practice you should become increasingly better at spotting what is important, and much quicker at recording it. Making studies from stuffed birds and animals can be useful only to a certain extent. The anatomical structure and the accuracy of the animal's pose are entirely dependent on the knowledge of the taxidermist. You can get the experience of drawing the texture and the particular markings of an animal in this way, but the drawing will inevitably be stiff and dead in the way that a drawing made from life seldom is, whatever its other faults.

Another approach to portraying movement is evident in this highly developed pencil drawing. Only certain parts of the bird were selected for attention by the artist in order to create a small area of focus. The wing-tip closest to us is clear, with the rest of the bird's form left indistinct so that it merges with the background. An eraser was used as a positive tool to lift out highlights and blend forms, creating ghost-like images.

BIRDS

Birds present the artist with an opportunity to test his or her drawing skill in recording a wide variety of sizes, shapes, and colors. Fortunately, there are many different places where birds can be studied. Many people have small birds in cages, and zoos usually have a selection of large and exotic birds on view. But, of course, wild birds can readily be coaxed down to your level if you have a bird table and some food to attract them or a vantage point which allows you to observe them unnoticed.

Birds are particularly popular subjects, and drawings of them are frequently converted into decorative designs. Often textiles use bird motifs, as their many different shapes and plumage patterns can be adapted to all manner of decorative treatments. Often drawings are made from stuffed birds. Such an exercise can be a very useful way of gaining experience in drawing feather textures and discovering the main features of a particular bird; but it is only by studying a bird moving in its natural habitat that one can succeed in capturing its true character.

This drawing represents a virtuoso performance of the line and wash technique. The artist has encapsulated the bird's personality with great delicacy and freedom. Pencil lines suggest both form and movement, recording the patterns of the plumage. Graphite stick and watercolor lay in the tone and colors.

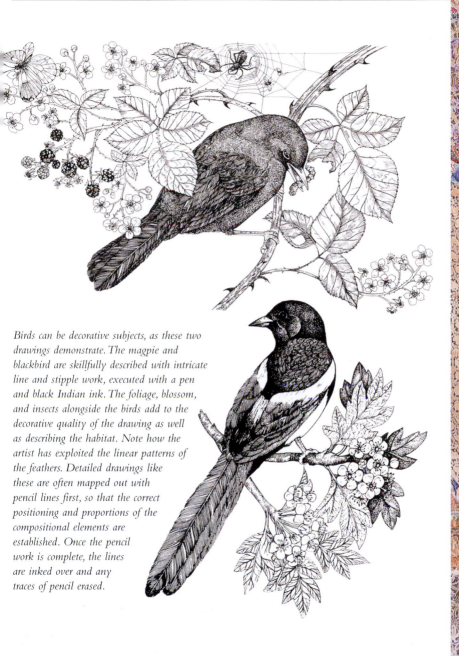

Birds can be decorative subjects, as these two drawings demonstrate. The magpie and blackbird are skillfully described with intricate line and stipple work, executed with a pen and black Indian ink. The foliage, blossom, and insects alongside the birds add to the decorative quality of the drawing as well as describing the habitat. Note how the artist has exploited the linear patterns of the feathers. Detailed drawings like these are often mapped out with pencil lines first, so that the correct positioning and proportions of the compositional elements are established. Once the pencil work is complete, the lines are inked over and any traces of pencil erased.

LIFE DRAWING

During this century the activity of drawing the nude figure, known as "life drawing," has not involved much anatomical theory and there is a tendency to try to understand the figure as if it were simply a geometric object.

During and after the Renaissance, artists equipped with anatomical knowledge were able to compose figures realistically from a preconceived repertoire, often using statues for models. Michelangelo had an extensive knowledge of anatomy, but this led him to draw figures in which the muscles were exaggerated to a degree unattainable in reality. In other words, each part of the figure was presented as though performing some activity requiring muscular force. Although Leonardo da Vinci realized that this wa false, it became common practice for artists to depict muscular structure without any indication of muscular activity. Gradually, it has become common practice to draw figures using the experience gained through observation combined with a certain amount of preconceived knowledge.

LOOKING AT FIGURE SHAPES

When we begin to draw figures, most of us draw a line that represents the outline of a person. This is partly the result of our experience of writing – making linear marks. It also has much to do with our innate ability to recognize things at a glance by their silhouettes. Although this is a vital survival skill, using it for drawing is unlikely to bring success, as concentrating on the line loses the solid presence. In fact, an outline marks the point at which a three-dimensional form turns and disappears from our view – much like the horizon that marks the perceived "edge" of a land mass or sea.

DRAWING NEGATIVE SPACES

Any outline of a figure must take into account both the solidity of the body and the surrounding empty space that defines it. For practice, stand in front of a large mirror, rest your non-drawing hand on your hip, and make a simple sketch. You will find that drawing the triangular space enclosed by your arm and torso is much easier than determining the angles of the upper and lower arm; drawing this abstract shape will help you to establish these angles. It also helps to practice using your peripheral vision.

By looking slightly past your subject, you place it just outside the focused center of your vision – which has a cone-shaped span – and thus see large shapes rather than details, which can be added afterward.

Negative Space
Because line drawing must take account of the negative space around the figure, which is seen as much as its poititve shapes, observe and draw them carefully. Here, the almost rectangular shape under the body defines the limbs.

UNDERSTANDING FORM

Because of the problems encountered in representing the human form, figure drawing is often assumed to be difficult. In fact, the hardest problem is the same for any subject: how to represent reality, or three dimensions, on a flat surface, which has two. The marks artists make show the lost third dimension by creating an illusion of form in space. Without light, form cannot be seen, so by representing light and its absence, shadow, the artist shows form. Volume is also perceived according to tone; dark areas look smaller than light ones the same size. For all these reasons, concentrating solely on line, and putting off adding tone and shading until the pose is defined, only makes the task harder.

BALANCING THE FIGURE

When drawing figures, look carefully at the body's ability to act as a self-balancing mechanism. In people, balance is achieved by constant adjustments between the upper body and the hips, so begin by checking whether the weight is being taken by one side or the other. Other factors to watch out for are foreshortening and perspective, which also require adjustments to be made to the symmetrical shape of the body and limbs.

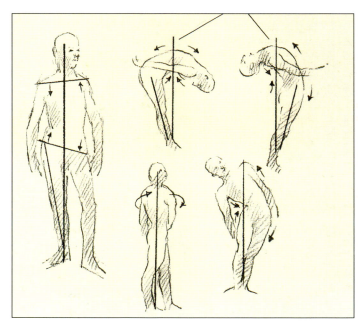

The vertical lines indicate where the central axis would lie in a figure standing at attention. The arrows show the direction of adjustments made to achieve balance in the poses.

DRAWING WHAT YOU SEE

The most important thing to remember is that your eye does not edit the form it sees. To create effective form, attempt to deal with all the elements you observe at the same time. These include the space around your model, which gives you both a cross-check from the negative shapes it creates, and a figure that is convincingly related to its surroundings. But don't try to re-create photographic reality. Because cameras can only focus on a single depth band or infinity, they cannot

select the essential information that shows form. However, you can, and a simple exercise will help. Make a figure sketch in full but light tones, then work backward, erasing faint tones first, then medium, and finally the darkest. As they are removed, you will see which marks were the most telling. The line drawing you end up with will enclose the form as white shapes, and you can then redraw the tones.

SELECTING YOUR VIEWPOINT

Before choosing a viewpoint, it is important to take time to study the exact position you wish to draw, the pose and its surroundings. This can be done by moving gradually around the model which will show the different angles and play of light on the form. The body's main volumes are basically composed of cylinders, each having a central axis and linking up with the spine, as the superimposed lines over these photographs show. When starting a drawing, a useful method is to work out the volumes in terms of cylindrical shapes.

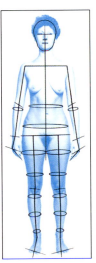

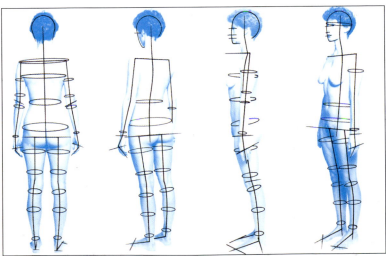

LIMB MOVEMENTS

These poses show the arm's relation to the rest of the body and the effect of its movements on the continuous muscles. By raising one arm, the whole of that side of the body is slightly raised, with both arms raised, the area above the waist is lifted and the muscles tightened. With the legs apart and arms down, the whole body has a more relaxed and heavier appearance, and the shoulders and chest muscles sag.

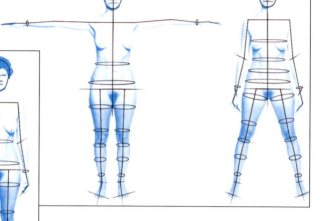

FORESHORTENING

These three poses demonstrate the apparent distortion of the figure through foreshortening from steep angles. On the left, the pose is telescoped. The feet appear to be enormous in relation to the rest of the body, the legs broad and short while the upper body is hardly visible. Viewed from above, the head and shoulders of the central pose dwarf the figure's lower half which diminishes into a V-shape. Artists should learn to measure by eye or by holding a pencil at arm's length, drawing entirely what they observe in front of them.

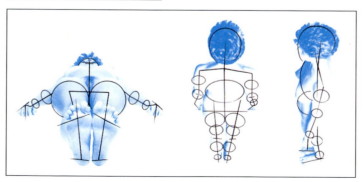

DISTRIBUTION OF WEIGHT

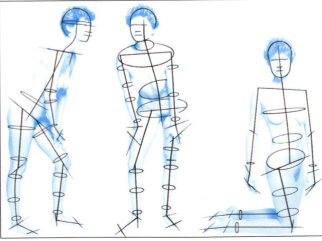

Because of its rhythmically co-ordinated structure, the body can fall into an infinite variety of poses, the slightest shift in position radically altering the whole effect. The five poses above show differences in the distribution of weight. With these types of pose, it is important to establish the axes of the figure and their spatial directions. With the axes worked out, the figure's directional lines should then be ascertained by studying the direction in which the different parts of the figure move and how they shift in relation to each other. Axes and directional lines help to establish the three-dimensionality of a form in space.

FEMALE FIGURE

With the exception of the obvious need to possess a basic knowledge of anatomical structure, particularly that of the skeleton, the main requirements for nude studies — one of the most popular types of female figure drawing — are the same as in other branches of drawing.

A sensitive, fresh approach to the subject of nude studies, however, is even more important than usual, though it is particularly difficult as far as the nude is concerned. It is an uphill, but essential, task not merely to imitate what has been done before, but to achieve an individual result. Never take a predetermined notion of "painting the nude" into the studio with you. The real task is to be inspired by what you see and to discover ways of interpreting it effectively. Risk mistakes, if necessary, in order to achieve this.

Detailed study of breasts, head, lips, and so on is one approach. Another is to relate the figure as a whole to the chosen setting. This involves a different way of working, with the nude becoming almost incidental in picture terms and certainly not the simple focal point it would remain if drawn completely independently of its surroundings. Most artists find this method the best; to establish basic planes of floor, walls, and so on to suggest scale via other objects is

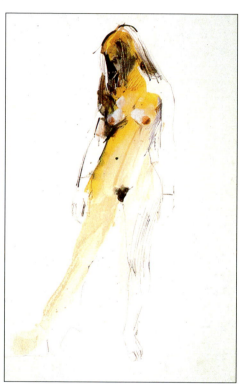

The diffidence suggested in the attitude of the model is reflected in this drawing by the use of quiet grays and the gradually fading yellow to round out the form. Strong modeling of the head contrasts with the simple, linear treatment of the arms and legs. This type of technique, combining pencil and watercolor is of equal importance in the drawing as a whole, can produce an intriguing effect.

rarely a waste of time.

This question of environment is even more important when it comes to drawing a clothed figure. The clothing itself will invite and suggest suitable settings, though not necessarily conventional ones. A flowing long dress, for instance, need not just suggest a ballroom or dance hall; remember it will also give emphasis to the lines of leg and hip that would not be discernable in a short dress or pants and this point should be brought out in the setting, as well as the drawing. In this case, it might be a good idea to stress this line by making a virtual silhouette of the figure as a whole, so that the torso leads into the fuller hip to create flow without the hinderance of excessive detail. Depicting the pull and creasing of folds over and across such a garment can also be intriguing and original.

The pose you select should also be original. A standing pose

might seem the way to get the most from clothes, but equally interesting studies can be made from a seated model. Try posing the model in a more complex position, with her hands featured, perhaps on her knees, or with her legs up on a surface parallel to the chair or stool on which she is sitting. Now observe the drooping, languid fall of the cloth from bent knee down to floor level. Such a pose can make a dress take on an entirely different meaning within the drawing.

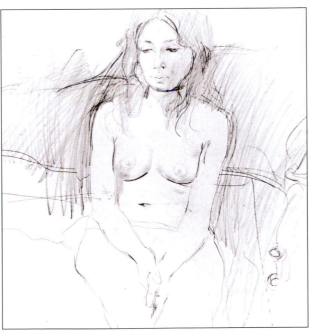

The figure here is described by contour lines, carefully drawn with a 2B pencil. Soft smudges of tone are occasionally included to round out the forms. The shape of the body is framed and pushed forward by the shaded area behind.

MALE FIGURE

The main characteristic of the male figure is that it is more muscular than the female one.

Choosing poses that reflect the muscularity of the male figure is particularly important. In a study of a mature man, for instance, the ideal pose to aim for is one in which tense, energetic line reflects the well-marked muscles. Study examples of the classical male figure form. This clearly depicts the breadth of the shoulders, tapering to slim hips, though age and other factors obviously affect this simple definition to some extent. Remember, too, that surplus fat sits on the muscles beneath the skin in different ways and places than it would on a woman.

The conventional "ideal" male figure is wedge-shaped – broad at the shoulder and narrow at the hip. However, men and boys come in all shapes and sizes, so look for any number of variations. Small boys may be scarcely different in size from little girls, but adult males are taller on average than grown women, and have a heavier upper body than a woman

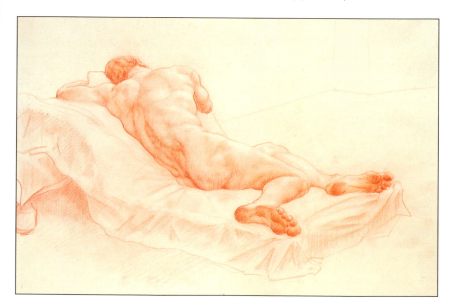

This is a beautiful drawing done with a Conté pencil. Catching the relaxation of the body so precisely with the clear definition of the muscles took a great deal of patient concentration.

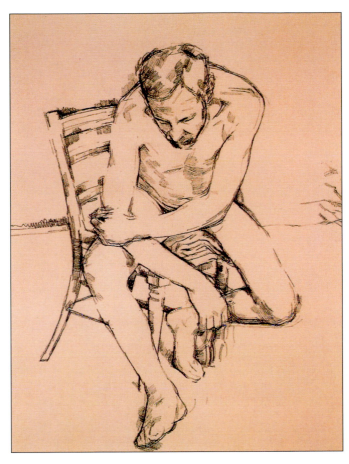

This very subtle pencil drawing of a man seated on a chair is a perfectly created three-dimensional form with the minimum of pencil drawing. The artist has obviously studied the work of Paul Cézanne (1839–1906) who wrote: "Treat nature by the cylinder, the sphere, the cone, everything in proper perspective so that each side of an object or plane is directed towards a central point."

of the same height. When drawing a portrait, note the stronger neck and heavier jaw on adult males; the other main physical difference is the lockable male forearm, carried at a different angle from that of a woman.

MALE PROPORTIONS

The head can be used as a unit of measurement in estimating proportions. When an adult is standing upright, with no foreshortening, it is a generally accepted rule that his body is approximately 7½ heads long. However, a baby is born with its head relatively larger than its body. As the child grows its head becomes relatively smaller in proportion to overall height.

HANDS

Hands are expressive indicators of emotions and states of mind, so it is worth taking time to understand their physical makeup.

Put simply, fingers are all cylindrical and jointed in the same way, but they seem complicated because each moves independently of the others, creating its own shapes. Their range of movement is, however, limited: they are either straight or bent, whether holding, gripping, pointing, or pressing.

In contrast, arms pose fewer drawing problems than hands, for the most part, so long as you check their lengths. Make sure you observe individual variations, and pay attention to the flatter planes that are near the wrists in all but the fleshiest persons.

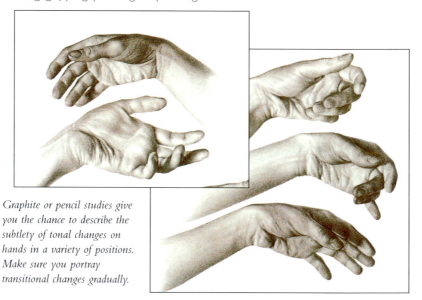

Graphite or pencil studies give you the chance to describe the subtlety of tonal changes on hands in a variety of positions. Make sure you portray transitional changes gradually.

GETTING TO KNOW YOUR HANDS

As an exercise in familiarizing yourself with hands, examine your own: are they tapered or spatulate, stubby or delicate, attenuated, broad-jointed, or dimpled? To show its form, place your non-drawing hand flat in directional light and draw the shadows cast by it. Then clench your fist and draw its triangular profile, completed by the thumb, with its larger, lower, offset

joint. Open your hand again and note how the palm tapers toward the wrist, which is a flexible link to the columnar arm. Make a series of sketches of your hand in various positions, making sure that you observe the relationships between the fingers and noting their characteristics. Once you have established the solidity and proportions, you can add details, such as creases, hair, veins, and nails; including a wristwatch or one or more rings helps describe contours. When drawing other people, look for the relationships between pairs of hands or clasped hands, and be aware of their size in relation to the rest of the figure.

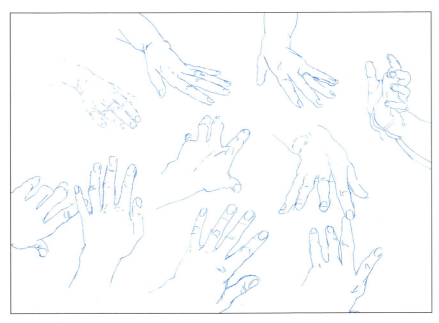

The hand

A complex series of joints in the hand make many combinations of movements possible. The flexible fingers of a healthy adult are capable of bending back some way over the top of the hand or of stretching across more than eight notes of a piano, while the other hand can simultaneously hold thin, fragile, or moving objects of almost any shape, although there are limits as to size. When drawing a figure, the artist soon becomes aware that hands are one of the most expressive features; Leonardo da Vinci was one of the first to notice and utilize this in his work. It is worth sketching them in different positions and from different angles to become familiar with the general form before incorporating them in finished drawing.

FEET

The foot is at least one head in length. As we have seen, the ankle joint permits movement freely forward and backward, with a limited rotation in the joint.

The foot and the ankle are not symmetrical. From the front the foot resembles an uneven triangle with the top cut off, sloping down on its outer side. The curve of the arch is visible only on the inner side of the foot. Put a wet foot on a piece of brown paper to form a footprint, and you will clearly see the flat outer edge, the arch and the curve of the toes. From the skeleton you can see how much the heel bone protrudes from the back, but what is not visible in the skeleton is the strong Achilles tendon, which connects to the top of the calcaneus or heel bone.

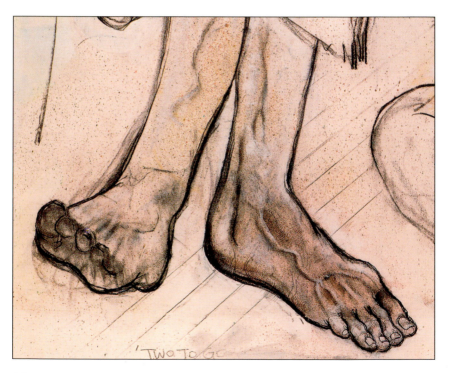

This is an interesting charcoal and pastel drawing in which the artist has observed not only the structure but also the individuality of the old feet, the metatarsal joints twisted from years of ill-fitting shoes.

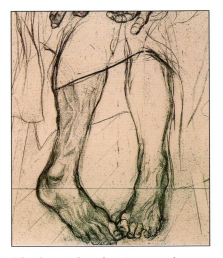

This drawing shows how important the expression of the feet can be in drawing.

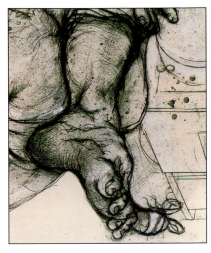

This twisted foot shows the construction of the heel and ankle very well. Students frequently underestimate the size of the heel when drawing the foot.

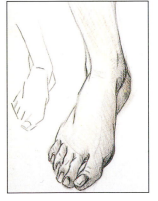

Conté drawing of the foot and ankle

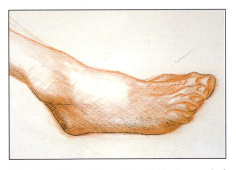

The hinge joint of the ankle with the large end of the tibia clearly drawn.

The ankle is formed by the ends of the tibia, the large shin bone, and the delicate fibula. These bones straddle the top of the foot and form the hinge joint. The large bulge on the inner ankle is the side of the tibia; it is higher than the fibula on the outer side. A good way to remember is that the lower ankle bone is on the sloping, outer side of the foot.

Drawing your own foot with the help of a long mirror is good practice and will save a lot of expensive model fees.

PORTRAITS

Successful portrait drawing demands the ability to create a solid, lifelike head and features that are a recognizable likeness of the sitter.

It is the likeness of the sitter that provides portrait drawing with an additional dimension over and above straight figure drawing. The basic problems of portrait drawing are concerned with the proportions of head and features, the asymmetry of the face and, above all, the identification of those characteristics that make the portrait instantly recognizable.

Cartoonists are often very clever at identifying and exaggerating the prominent nose or receding chin of a celebrity they wish to lampoon. Although the degree of exaggeration needs to be reduced, the portrait artist should take a page out of the cartoonist's book and concentrate on the salient features by analyzing the head. Matisse's comment that accuracy is not the truth, probably relates to portraiture more than to any other form of art.

There are various approaches to drawing portraits. It can be a slow, methodical construction of the head, looking carefully for the difference between the two sides of the face – which are never symmetrical. Few noses, eyes, or mouths are classically equal, and identifying these minute differences can help to produce a good likeness. Alternatively, you can go directly for those elements of the features that you consider characterize the sitter; these could be the main shape of the head or details

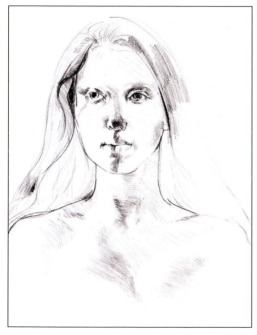

Soft pencil produced the sensitively sculpted form of this portrait. The contours and subtle modeling of the upper chest and throat are expressed with hatching.

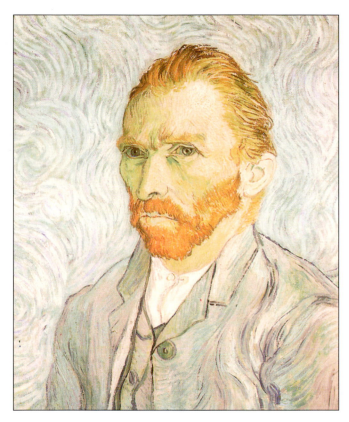

of eyes, nose, lips, and hair. Once these main characteristics have been captured, the drawing can develop around them to whatever degree of detail the artist requires.

SELF-PORTRAIT
BY VINCENT
VAN GOGH

THE SELF-PORTRAIT

Because the history of portraiture is studded with so many fine gems, to find one's own language, to avoid the pitfalls of sentimentality and deadness, is often difficult. Many artists use the self-portrait as a way to guarantee a consistent model and to allow a subject for experiment, both with descriptions of form and the way of approaching problems.

Throughout the centuries man has ventured to create images of himself,

often using the self-portrait as a background figure or as a character in animation. The self-portrait as an art form, in its own right, was taken to very high levels of achievement by Rembrandt, van Gogh, and Cézanne, all of whom used it to discover their personal means of picture making. It remains an extremely useful way to gain knowledge and will give aspiring portraitists valuable opportunities to experiment and risk making mistakes.

FEMALE PORTRAIT

Throughout her lifetime, a woman's face can reflect many moods. At any given time, for instance, the same features within a mother's face can show love, concern, worry, or compassion – qualities that are reflected in quite a different way from the same ones in the face of a man. The task of the artist, therefore, is not only to depict accurately the physical differences between female and male features; it is also to capture these inherent, subtle, variations in emotional reaction between the two.

As in all drawing, the best way to learn is through experience, both in terms of practice and close observation. The latter allows you to assess even more than immediate and instinctive reactions and enables you to recognize – and capture – every extreme nuance of expression, however understated.

Above, in a smile, the eyes are narrowed from below, resulting in the upper parts catching the light, creating the well known "twinkle in the eye."

GIRL IN BLUE JEANS
BY KAYE SONG TEALE
Both the pose of the figure and the facial expression suggest a rather downbeat mood, but the pencil marks and colors are, by contrast, extremely lively.

MALE PORTRAIT

The male face is dominated by extremes; its harder, more acute, lines must always determine the general feel of the finished drawing. Male portraits, therefore, should be approached in a different way from those of women, or children. Lighting becomes particularly important, because the harder, bony brow of the male, the deeper recesses below the lower lip and above the chin, and the thicker neck will all be better seen through high contrasts of tone. Traditionally, figures are lit from above, but drama can be increased and features emphasized by use of a different lighting system. One interesting variation is to light the sitter from both sides, with one light striking the subject directly and the other bounced from light paper. If the sitter has interesting features, best seen in profile, back lighting can be a useful method.

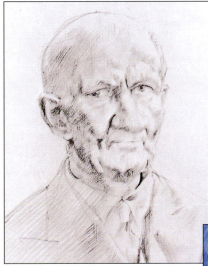

Above, when drawing portraits it is important to understand the relationship of the skull to the head and face and the way in which this differs according to the age of your subject. In an old person several changes are apparent, among them are the loss of teeth and a consequent loss of importance in the lower part of the face.

SOLDIER BY LINDA KITSON
The straightfoward frontal view of the head provides a sense of the model as a person of strength and direct action. The mood of the portrait is not aggressive, however, as the lines of the face convey.

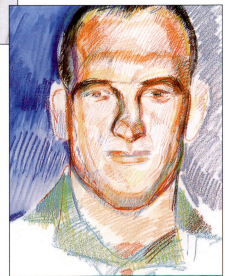

DRAWING A PORTRAIT IN COLORED PENCIL

This picture is a good example of the effective use of colored pencils in portraiture, especially when combined with the color of the clean white surface.

Although the artist has used line to develop tonal areas, the method of drawing is similar to the classic oil painting technique of laying down colors one over another to "mix" new colors. This requires a confident use of color, as once put down, colored pencils are not easily erased. This, combined with subtle or strongly directed strokes that follow or exaggerate the planes of the figure, creates a powerful image.

An interesting feature of the composition is the use of the white paper within the figure to describe the face, hands, and hair highlights. In the model's left hand, one simple line is all that is needed to separate the figure from its environment. The nearly bare areas of the face and hands are heightened by the surrounding dark area, which, in turn, plays off against the white of the paper.

In the final stages of drawing, the artist reworks dark detail areas with a strong blue pencil.

1 Sketch in the outline of the face in raw umber. Use ultramarine blue for shadows and hair and very light strokes of the same color in the blouse.

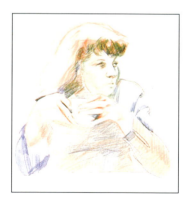

2 With pale green, begin to define shadow areas of the face with very light hatching and cross-hatching. With dark blue, put in the eye details.

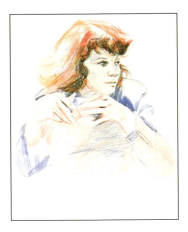

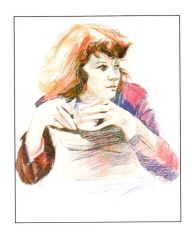

3 With red and yellow, put in loose strokes to define hair tone. Strengthen outlines of face with ultramarine blue. Put in dark shadow area to right of face.

4 Work into the hair with directional strokes of red. Overlay light strokes of blue and red in the blouse with loose, scratching strokes.

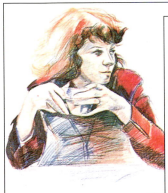

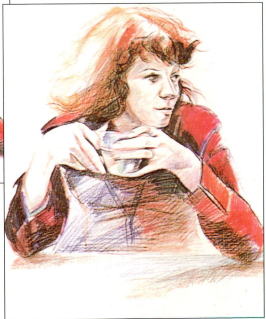

5 Overlay magenta area with red. Create stronger shadow areas with ultramarine blue. Then work back into hair with burnt umber. Use pale green to put in highlights in the cup.

The finished drawing

CHILDREN

Children's faces contrast strongly with the strong, sculptured look often found in the head of a man and the elegance and interest of a mature woman's expression.

Children's faces deserve special study. One basic fact to remember is that there is a continuing change of proportion over the years as opposed to the slower rate of change in the adult face.

In babies, for instance, all the facial details are small in relation to the size of the head, while the neck, which at the earliest stages cannot support the head, remains thin and unstable for quite some time. Its entry into the base of the cranium also differs markedly from that of the adult form. The cranium itself grows only slightly larger, but the eyes seem over-large at this stage.

Such factors present serious, but not unmanageable, problems. In addition, there are others, not the least of which is the problem of pose. Since it is a prerequisite of portraiture that the subject must remain at least tolerably still for long enough for the eye to sum up the overall form and probe deeper into individual shapes and nuances of line, choose an easy pose at first. A sleeping baby is often an ideal first study.

From such studies, you will gain the experience necessary to progress. In general, the techniques to be followed are very similar to those you would adopt for drawing wild life.

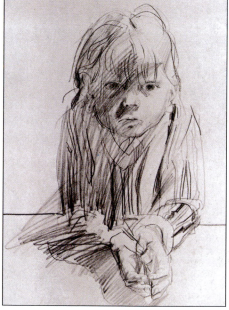

This child was drawn quickly using a 2B pencil on plain white drawing paper to capture the pose before the boy moved. The hands were emphasized, almost to the point of distortion, to provide a foreground focal point and increase the sense of depth.

Pencil marks have been used here not only to delineate the form but also to give overall tone.

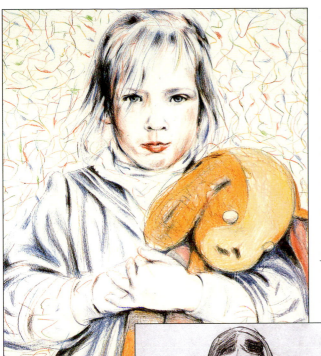

CHILD STUDY BY ERIK VAN HOUTEN

A direct frontal pose typically has a confrontational mood, but here this is made ambiguous by the child's posture, which seems to draw back slightly from the viewer, and the cuddly toy she clutches, as if in need of a friend. Her face, though, is strongly drawn, with decision and clarity in those features which form the important focal points of a portrait – the eyes and mouth.

A soft pencil can produce both line and tone with ease and is ideal for this type of developed sketch. Children are notoriously difficult models and cannot be expected to sit completely still for long. You need to draw quickly, therefore, trying to capture the sense of latent energy and movement before it is physically expressed by the sitter. Here the lines are gentle and flowing capturing the relaxed pose of the model.

FACIAL FEATURES

The muscles, flesh, and skin that conceal the skull provide an endless range of variations, but it is vital to delay adding detail until you have established a broad likeness.

EYES

The best way to study the eye's structure is to draw it from the side. The eye fits into the orbit of the skull and is overshadowed by the protruding brow.

Make sketches of individual eyes, concentrating on describing the spherical nature of the eye (think of the eye as resting inside the circular cup of the socket). Note how the eyelids change shape according to the direction of the gaze.

MOUTHS

It is easiest to gauge the true dimension of an individual mouth by drawing it in relationship to the other features, as these help to establish its proportions and position.

Spend some time with a friend or sitter, recording the conversation with studies of a speaking or smiling mouth. Work quickly, and revisit each study to finish repeated movements, as in examples here.

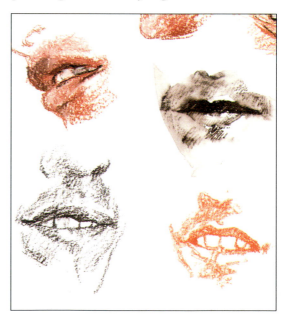

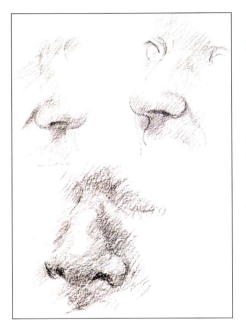

NOSES

To give form to a nose you will need to think in terms of tone, not line. It is vital to show the way it stands out from the face, and if you restrict yourself to purely linear marks, you are likely to achieve a flat, two-dimensional effect. Lines serve to mark the boundaries of tonal changes, and while they may be perfectly adequate to depict a profiled nose against a contrasting background, or even a three-quarter-view nose where the bridge and nostrils contrast with darker or paler cheeks, they won't help you to tackle the graduated lights and darks of a nose in a full-face view.

Make studies as seen above. If noses cause you problems in drawing, allocate a page or two in your sketchbook for studies. Regular practice improves your drawing skills, so add to the pages whenever possible.

When drawing ears, include the adjacent information from the hair, neck, and jaw, to help you define the basic shape.

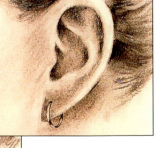

EARS

Artists who gloss over ears, seeing them as an unimportant – or too difficult – aspect of portraiture, are missing an opportunity to convey character, as these are singularly distinctive features. Ears are not easy to draw, but the key to success is to focus on the three-dimensional aspects initially, rather than beginning with a linear rendition that can create a flat effect.

219

GLOSSARY

Aquarelle A drawing colored with thin washes of watercolor paint.

Blocking in A technique of roughly laying out the forms and overall composition of a drawing in terms of mass and tone or color.

Body color Paint, such as gouache, which has opacity and covering power.

Calligraphic A term referring to a linear style of drawing, characterized by flowing, rhythmic marks.

Caricature A represent-ation of a person or object showing the characteristic features exaggerated.

Cartoon A drawing or sketch, sometimes containing an element of caricature, showing the comic side of a situation, can also refer to a full size drawing made to map out the composition for a large painting, mural, or tapestry.

Charcoal A drawing material made from reducing wood, through burning, to charred sticks.

Collage Collage is a technique of creating an image or composition by glueing down scraps of paper, fabric, or other materials.

Composition The arrangement of various elements in a drawing, for example, tone, contour, color, etc.

Conté crayon A drawing stick like a hard, square-sectioned pastel, available in black, white, gray, red, and brown.

Cross-hatching A technique of laying an area of tone by building up a mass of criss-cross strokes, rather than with a method of solid shading.

Figurative This term is used in referring to drawings in which there is a representational approach to a particular subject, as distinct from abstract art.

Fixative A thin varnish sprayed onto drawings in pencil, charcoal, pastel, or chalk, forming a protective film on the work.

Foreshortening The effect of perspective in a single object or figure, in which a form appears considerably altered from its normal proportions as it recedes from the artist's viewpoint.

Golden section A canon of geometric proportion, used by some artists since classical times.

Grain The texture of a support for drawing. Paper may have a fine or coarse grain depending on the methods used in its manufacture.

Graphite A form of carbon which is compressed with fine clay to form the substance commonly known as "lead" in pencils. Thick sticks of graphite are available without a wooden pencil casing.

Ground The surface preparation of a support on which a drawing is executed.

Half tones A range of tones that an artist can identify between extremes of light and dark. These are often represented in drawing by techniques of hatching or stippling.

Hatching A technique of creating areas of tone in a drawing with fine, parallel strokes following one direction.

Masking The use of adhesive tape or masking fluid to protect an area of a drawing while paint is applied to another area.

Medium This term refers to the actual material with which the drawing is executed, for example, pastel, pencil, or charcoal.

Modeling In drawing, modeling is the employment of tone or color to achieve an impression of three-dimensional form by depicting areas of light and shade on an object or figure.

Monochrome A term describing a drawing executed in black, white, and gray, or only one color mixed with black and white.

Perspective Systems of representation in drawing that create an impression of depth, solidity, and spatial recession on a flat surface.

Picture plane The vertical surface area of a drawing on which the artist plots the composition and arranges pictorial elements which may suggest an illusion of three-dimensional reality and recession in space.

Resist This is a method of combining drawing and watercolor painting, a wash of water based paint is laid over wax crayon or oil pastel.

Sepia A brown pigment, originally exracted from cuttlefish, used principally in ink wash drawings.

Silverpoint A method of drawing using a silver-tipped instrument on a ground specially prepared, such as gesso.

Spattering A technique of spreading ink or paint in a mottled texture by drawing the thumb across the bristles of a stiff brush, loaded with wet color.

Stippling The technique of applying color or tone as a mass of small dots, made with a drawing instrument or the point of a fine brush.

Study A drawing often made as a preparation for a larger work.

Support The term applied to the material that provides the surface on which a drawing is executed, for example, board or paper.

Tone In drawing, tone is the measure of light and dark on a scale of gradations between black and white.

Torchon A stump made up of tightly rolled paper, pointed at one end, which is used for spreading or blending material such as charcoal and graphite.

Underdrawing The initial stages of a drawing in which forms are loosely sketched or blocked in before elaboration with color or washes of tone.

Value The character of color or tone assessed on a scale from dark to light.

Wash An application of paint or ink considerably diluted with water to make the color spread quickly and thinly.

INDEX

PICTURE CREDITS

The material in this book previously appeared in:

The Complete Drawing & Painting Course; How to Draw and Paint; The Complete Artist; How to Paint & Draw; The Encyclopedia of Illustration Techniques; The Encyclopedia of Flower Painting Techniques; How to Draw & Paint Portraits; The Encyclopedia of Drawing Techniques; The Encyclopedia of Colored Pencil Techniques; How to Draw & Paint Still Life; Figure Sketching School; How to Draw in Pastels; Pencils and Pen & Ink; You Can Paint Flowers, Plants & Nature; An Introduction To Drawing; Drawing and Sketching; The Artist's Manual; The Painting & Drawing Course; Drawing and Painting the Landscape; Drawing the Nude; Sketching Planning & Drawing; How to Draw & Paint From Nature; How to Draw & Paint the Figure.